DISCARD

D1062654

WINTER PARK PUBLIC LIBRARY
460 E. NEW ENGLAND AVENUE
WINTER PARK, FLORIDA 32789

DISCARD

WINTER PARK PUBLIC LIBRARY
460 E. NEW ENGLAND AVENUE
WINTER PARK, FLORIDA 32789

By Rory Kennedy | Foreword by Robert Coles

American Hollow

Photographs by Steve Lehman
Interviews by Mark Bailey

BULFINCH PRESS
LITTLE, BROWN AND COMPANY
BOSTON NEW YORK LONDON

Foreword by Robert Coles

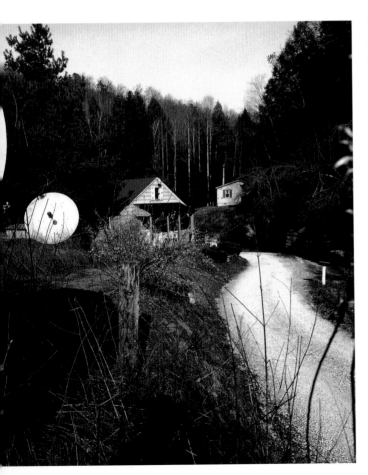

What follows are words and pictures that tell of a particular way of living, still, in late twentieth-century America. What follows, too, is a tradition of documentary work given new energy and expression by a film-maker and her colleagues, a writer and a photographer, who had the determination, the willfulness, the resourcefulness that took them from a city life to a relatively inaccessible rural life. This book celebrates one exemplary Appalachian family, the Bowlings, whose lives, worries, and stories, well-remembered or near-forgotten, are destined to now be told. What follows, finally, is an effort at understanding, an attempt to learn how life goes in a region not known for its wealth and power, no matter its compelling beauty and the ardent devotion it has claimed for so long from those who have worked this mountainous terrain known as Appalachia.

In a sense, hope informs the pages ahead—the desire and the intentions of Rory Kennedy and her colleagues, Mark Bailey and Steve Lehman—that through interviews conducted, and photographs taken, a hollow's inhabitants be given voice, and their appearances and gestures, their hard toil and their fun moments, be put on the record. The further hope, of course, is that the rest of us take notice of Appalachia, that we become thereby connected in mind and heart to a people both proud and vulnerable, who are at a distinct remove from us, even as

they salute the same flag we honor, speak the same language we favor. Under such circumstances a nation lives up to its name. We who live in various states become united as readers and viewers to the people in this book—"mountain-eers," as many of them call themselves, men and women and children quick to regard theselves as belonging to one or another hollow, and anxious to keep hold of their present-day acreage, even as they yearn for a more secure and comfortable life.

I worked in Appalachia as a young physician and it speaks to me now, as it did strong and clear, back then. "Hereabouts it's God smiling on us," an Appalachian mother once told me, as she contemplated with affection and vivid nostalgia her family story, not unlike stories told in these pages. But she was at pains to mention, with unashamed candor, the drawbacks that she knew constantly stood in the way of her children's educational and vocational progress. "We pay a price for all this beauty we have here," she commented once, with a kind of wry detachment that comes to someone trying hard to take a long view of things, even as she knew in her heart how much that Eastern Kentucky hollow meant to her and her kin. Then, as if to anticipate questions she spelled out what she had in mind: "We hold tight to what we have here—the hollow is in our hearts. But my young ones don't have the schooling they'd

need if they lived yonder, in a city—and there are no jobs for them. We've got our land, true, but if that gets hurt, we'll have to leave."

She was letting me know, loud and clear, that like many other Appalachian parents, she wanted a better education for her sons and daughters, and better prospects for them. She wanted the possibility of work then not available, and even now, up many hollows, not to be had. For this region's youth is forced to leave their families and seek jobs (and job training) elsewhere—find in the cities of Ohio, say, or Illinois or Michigan, a more promising, fulfilling life. And with that last expression of apprehension, she was referring to a growing threat—that even the precious grace and dignity of a hollow's life might one day be tarnished, threatened by those who dig the land for coal, pollute rivers and streams, assault stretches of timber, and thereby lay waste even to the isolated rural splendor her hollow and others could, as yet, enjoy.

By implication this book asks us as a nation to stop and think about how we might do better by a people and a region which struggles constantly to make do. How can we come to the helpful assistance of our American hollows, and of those whose present-day fate is so significantly circumscribed by such places—by their constraints, no matter their strong pull on the families who live by and for them, hard though it may be to do so?

In the middle 1960s some of us physicians who had worked in such hollows, and knew the hardships many of Appalachia's children have had to endure, took our medical research, our information, to Washington, D.C., there to enlist the support of willing legislators and government officials. In that regard, no one was more interested in those hollows, their parents and children, than the then-Senator from New York, Robert F. Kennedy. I can still see him listening attentively, hear him speaking with an earnest, incisive voice as he tried to make clear his humanitarian convictions, to rally support to a moral cause in which he very much believed. "I have been to those hollows," he told us, with great feeling, after we recited our experiences, our concerns.

And now, a full generation later, the youngest of his children has come to us with a similar empathy and compassion—like her father, with a willingness to lend her generosity of spirit to others very much in need. Here, then, with the informative and affecting stories of the Bowling family told in *American Hollow* (the documentary film and this documentary book) a daughter links arms with her father, offers news of a region's continuing story, and exemplifies, yet again, her family's continuing commitment to others in need, her family's unfolding American story.

Introduction by Rory Kennedy

American Hollow is a many-textured story about a hardscrabble life of poverty in a beautiful and unspoiled landscape. It is the story of the Bowling family and its remarkable matriarch, a staunch and spiritual support to her family in hard times.

I had the unique opportunity to live with the Bowling family on their land on and off over the course of one year. Introduced to them in 1996 by a social worker in eastern Kentucky, I planned to document the impact of the new welfare laws on poor rural communities. I wanted to show that poverty is pervasive in all areas, and that the system was failing to meet the needs of many, especially in economically depressed regions like Appalachia. Early on in the process, it became apparent that the Bowlings were not going to fit my preconceived notions about poverty in Appalachia. I stopped asking questions about how they might consider themselves "victims" of the system, and instead allowed the characters to lead me. It was then that remarkable stories evolved. *American Hollow* is not an attempt to answer questions about welfare policy or to create a portrait of victims. Rather, it aims to raise questions about poverty and injustice, to delve into issues of modernization and industrialization. A celebration of family and community, *American Hollow* ultimately asks what is lost and what is gained when tradition dies out.

I had long been interested in this remote mountainous region that runs across thirteen states between southern New York and eastern Mississippi. My father, Robert Kennedy, went to West Virginia in 1964 and was deeply moved by what he saw. He met families with children who were uneducated and malnourished, without health care or resources to help themselves. He spent time in dilapidated one-room shacks that housed families of eight or more. Many of these families could not afford electricity or running water, and sewage from outhouses drained into the streams that they used for bathing and from which they took their drinking water. My father's visit to Appalachia made a profound impression on him and inspired me to learn more about the region.

We expect Appalachia to be a place of inbreeds and six-fingered children, of hillbillies and moonshine, an America more backwards than backwoods. But in my year with the Bowlings, I discovered that the truth is

THE BOWLINGS HAVE LIVED IN SAUL FOR
OVER SEVEN GENERATIONS. MORE THAN
FORTY BOWLINGS LIVE THERE NOW.

not so simple. Early on, the Bowlings and I forged a
powerful connection. They immediately opened up
their home to me, and as I spent more time with them,
I was struck by their sense of dignity and pride as they
survived life in this forgotten corner of America. There
are, at present, over forty Bowlings living in Mudlick
Hollow, a mile-wide valley located in one of the poorest
and most isolated regions of eastern Kentucky.

Like much of the Appalachian population, the
Bowling clan fits the profile of a poor rural family
struggling for such basic needs as health care and
education. Homeowners with a deep regard for land
and family, the Bowlings' uniquely American lifestyle
continues to be threatened by a lack of job opportunity
and dwindling welfare spending. Due to their isolated
existence (nearly an hour's drive from the closest town),
the Bowlings rely on family and community for support.

With jobs so scarce in the mountains, many
Appalachians are gradually lured down from the hills
to work at the malls and fast-food restaurants of a
rapidly encroaching society. Yet the Bowlings have
managed to hang steadfastly on to their land, family,
and tradition. Most of the Bowlings who live in the
hollow receive government assistance and supplement

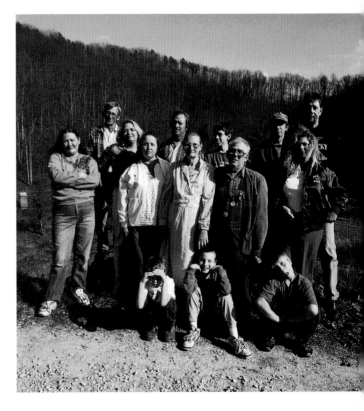

that income with produce from the land; Iree and Bass cultivate an impressive garden and their sons earn additional cash by collecting bloodroot, ginseng, and moss.

The Bowlings' world seems a strange echo of our American heritage. For seven generations, this family has survived in Saul, Kentucky, through hard work and sacrifice. Iree Bowling, sixty-eight, is the matriarch of the Bowling family and the firm voice that helped me to understand life in this American hollow. Iree and her husband, Bass, have reared thirteen children and Iree continues to care for her bedridden mother and her mentally retarded sister. She grew up on the same land on which she presently resides and has only left the region for a total of four months in all of her sixty-eight years. Although her children are now raising families of their own, they continue to look to her for strength and spiritual guidance.

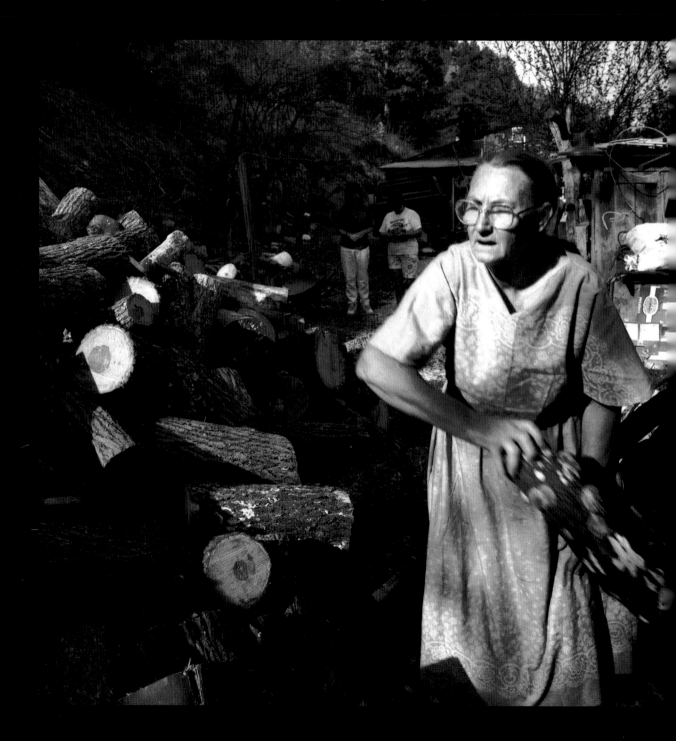

"I feel like
I'm rich, rich as
the Lord wants
me to be."
— Iree Bowling

In addition to raising her family and cultivating her garden, Iree celebrates her heritage and Appalachian tradition by making and selling beautiful and intricate quilts. When I first arrived, she told me that "no one had bought a quilt in over seven years, since no one has been round here to buy one." But, she continues to spend her winter months quilting: "because my mother quilted and her mother quilted, so I suppose that's why I do it."

Although I came to admire the Bowlings' dedication to family traditions and the self-reliance of living off the land, I also saw a family struggling with very contemporary problems—domestic abuse, drug and alcohol addiction, and the consequences of reduced welfare. Iree herself was raised in a violent home. Edgar Bowling, her son, recently spent seventeen days in jail for a crime he did not commit, her granddaughter, Samantha Canada, is attempting to break away from an abusive relationship with her husband, Iree and Bass have trouble with their health. In each of these circumstances, we see family members struggling with very real economic deprivation. I found that many of the chidren were torn between a dependence on welfare, a desire to work, and an unwillingness to leave the home they love. While each of Iree's thirteen children have at different times moved out of the hollow, in the end all but one have returned: "They know that here at home, they'll never have to do without—they will always have food to eat and a place to rest their head," says Iree.

Many people ask why the Bowlings agreed to participate in *American Hollow*. I think the answer is that they are a kind and loving family who would open their home to most anyone who came their way. They were a brave and courageous family to allow me into their lives, knowing that I would leave with a document—a film and now a book—that represents them to the world. But further still, Iree and her family also seem to know that they have something unique and special in Mudlick Hollow; something that is distinctly different from a more fast-paced city life. Theirs is a life based on family and community, working the gardens and hunting in the hills, celebrating tradition with quilting and storytelling. They are proud of what they have and are willing to share it. Moreover, Iree Bowling in particular has dedicated her life to preserving culture and tradition and keeping her family together. She sees her children with television sets and satellite dishes, her son Lonzo addicted to Prozac, the closing of the little schoolhouse at the edge of the hollow where she and her children learned to read. Ultimately, I think she knows that her way of life won't survive much longer. And perhaps she feels that in some way, American Hollow is a way of preserving it for generations to come.

THE FAMILY MATRIARCH, SIXTY-
EIGHT-YEAR OLD IREE BOWLING,
STACKS WOOD FOR THE WINTER.

IREE BOWLING

"Same love as the day we got married fifty years ago. Ain't no difference in that."

My great-granddad bought this land and gave it to my grandma, gave it to his daughter. I really don't know where he came from, how he got the money. But he bought it, the forty-four acres where I live. Then my grandma give the land to my daddy, and then Bascum and me, we bought four acres from Daddy, four acres more or less following the lines, you know. And I've got heirs to the other land.

So this is my mother and daddy's home. There was eleven children raised here and most of them are still living. And my mother will be ninety-one in September. My daddy, he died in 1980. He was eighty years old and never did live no place but here—and on down at the foot of the hill. As for my brothers and sisters . . . one sister and one brother lives in Florida. And Lillie lives in New Richmond, and Ellen lives in Ohio To tell you the truth, I don't even know where all of 'em lives. They're all younger than me; I'm the oldest. Most of them left when they was eighteen and I just stayed on. I guess they wanted to go and find a job to work. My sister Marion lives right down the road and Tester, my baby brother, he comes to visit. He lives in Carlton, Kentucky. I see him more often than I do the rest of them.

But we've had a homecoming out here at Mommy's for the last twenty years. We tell the family

IREE AND BASCUM (BASS) BOWLING HAVE BEEN MARRIED FOR FIFTY YEARS. IN ALL THAT TIME THEY'VE NEVER SPENT MORE THAN A FEW DAYS APART.

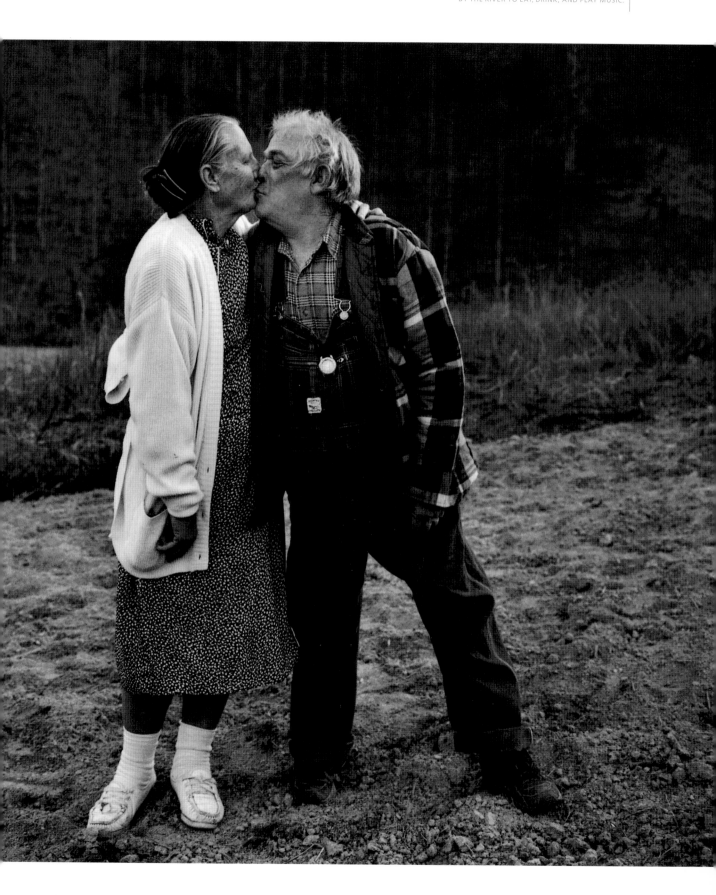

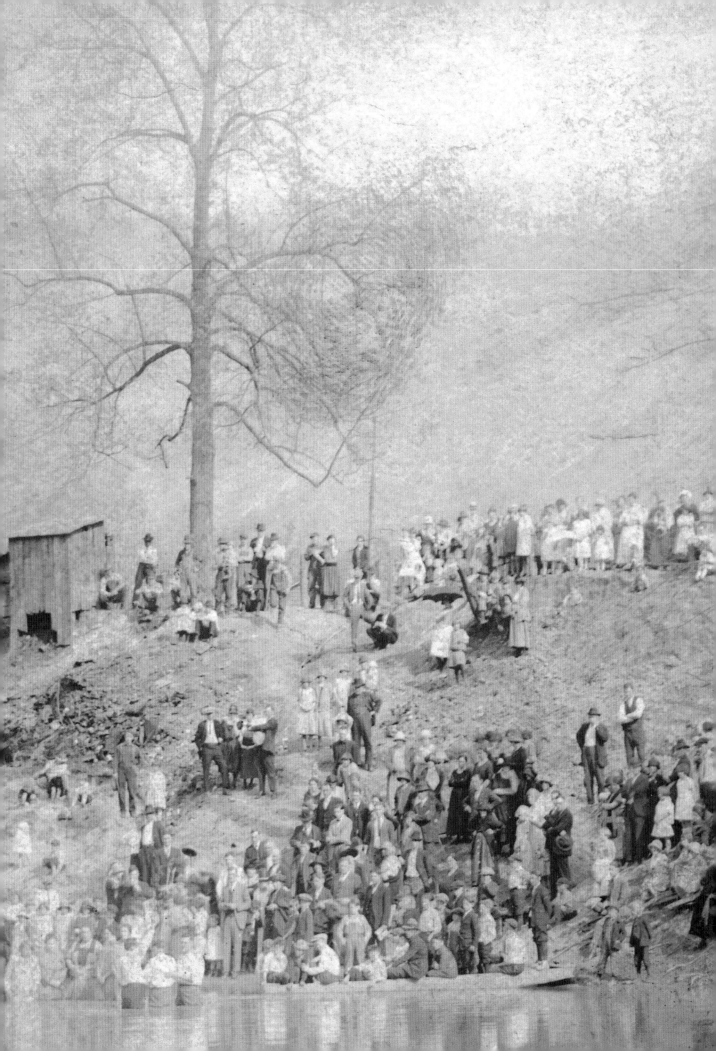

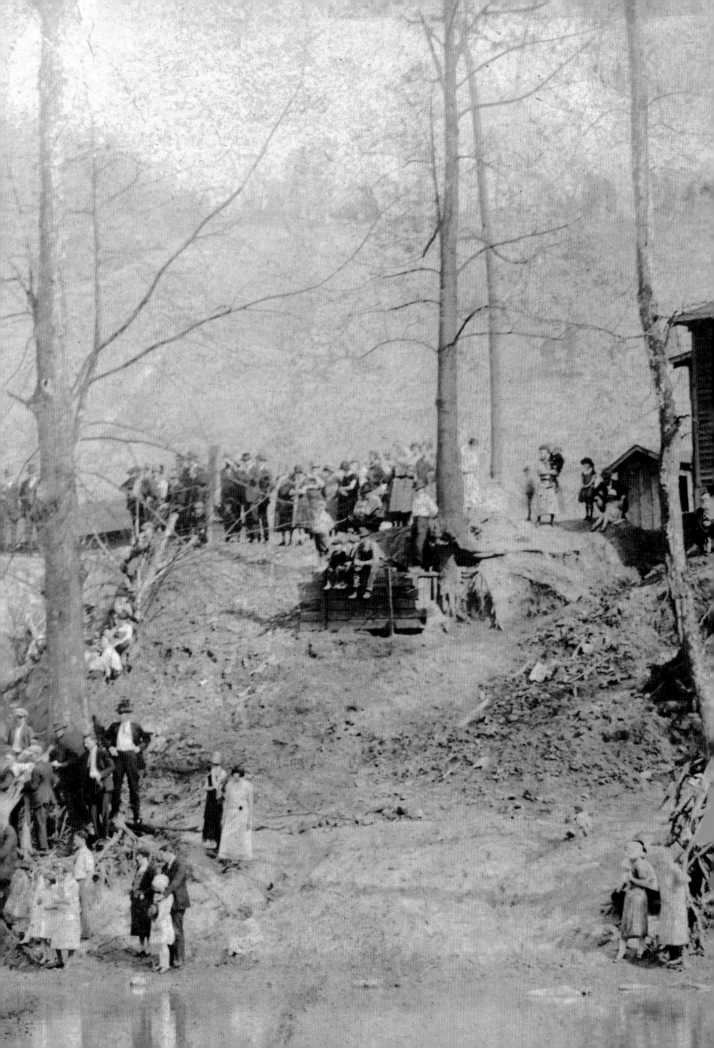

BASS BOWLING (CENTER)
AND HIS SISTERS HAZLE (LEFT)
AND DOROTHY (RIGHT).

THE RICE FAMILY BEFORE THE LOG CABIN WHERE IREE GREW UP. IREE'S FATHER, IRA RICE (STANDING RIGHT), HOLDS HER BROTHER LESTER, WITH HER MOTHER OMA BESIDE HIM. IREE HERSELF IS STANDING BEFORE HER MOTHER. IN FRONT IREE'S GRANDMOTHER NANCY RICE (LEFT) AND A VISITING NURSE, MISS PRICE.

"There was no road back then, just a little path to get up in the holler. You could ride a mule, or drag a sled, or walk. People survived."

from year to year what time to come. We don't call them, we just tell them at the homecoming when to all meet back here the next year. This year it will be on the fifteenth. Sometimes there's maybe seventy-five people, one time there was a hundred and fifteen. They're all family, different parts of the family. Maybe some of thems are Collings, some Rices, and some Bowlings and some different ones married into other families. Minnie's children, Mommy's sister, come from Indiana. A whole bunch of them. Homecomings been goin' back to long before I can remember.

We make a big dinner and everybody gets together and we sing songs and play music and somebody preaches. They have a memorial service up at the cemetery or out there in Mommy's yard and everybody gets together and prays. The memorial homecoming service. I've been cooking for it for about twenty years. They used to have the service, but they never had no dinner. I'm the one that started the dinner. The memorial service goes back to I guess in '39. My aunt before she died, her son Johnny Morris was buried up there in the family cemetery and she wanted to start church up there. I've got two grandmas buried up there and a stepgrandma and my daddy and my sister and my great-grandbaby Deborah. I wouldn't ever want to move away from the family cemetery.

I was born in a big log house just down the holler. It used to have a big old chimney and Daddy would saw big logs of wood and roll them in to make a fire. I guess I was probably about twelve years old when they built the new house. I slept in a room with ten of my brothers and sisters. See, we had three beds in there and all the kids slept together. And as long as Daddy was living, we carried water from the spring to the house. After he died, Mommy had a well drilled, in 1982. I paid fifty dollars a month until I'd paid up the seven hundred dollars for that well. Running water in the house and bathroom—that was something I never was raised on.

There was no road back then, just a little path to

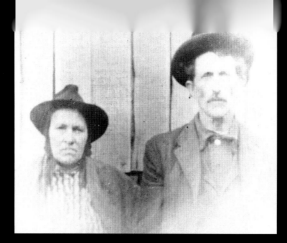
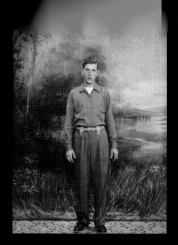
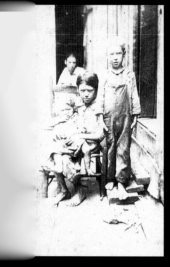
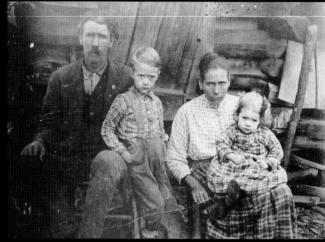
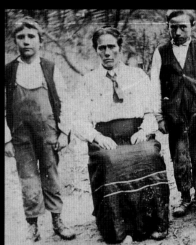

TOP ROW, FROM LEFT: U.S. AND EARL COLLINGS; UNKNOWN; LESTER RICE (IREE'S BROTHER); IRA RICE (IREE'S FATHER); ANNIE AND GREEN BOWLING (BASS'S PARENTS); ANZ WEST ON HORSE (IREE'S UNCLE). MIDDLE ROW, FROM LEFT: NANCY, NONELEE, OMA AND ANDREW WEST (IREE'S MOTHER AND UNCLE); COLLINGS FAMILY: LEVI, WALKER, RACHEL WEST (IREE'S AUNT), AND SARAH JANE; HENSON AND SALLY WEST (IREE'S GREAT-GRANDPARENTS); NANCY WEST (IREE'S GRANDMOTHER); WAVEY AND

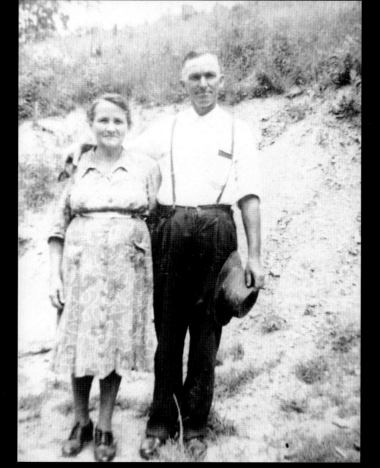

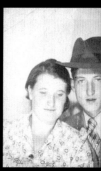

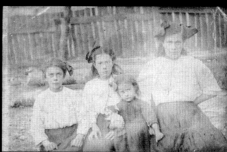

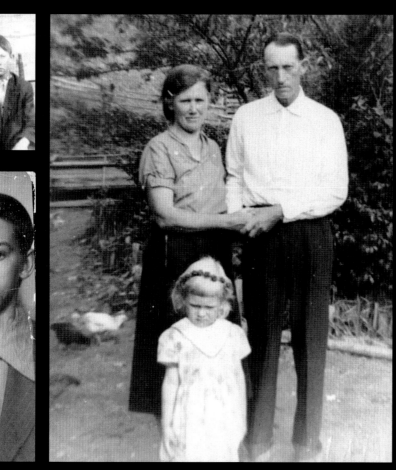

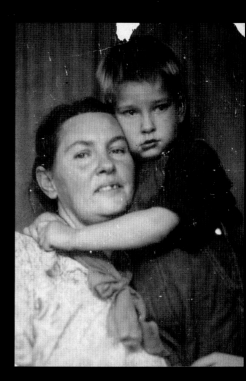

BOTTOM ROW, FROM LEFT: ANCE COLLINGS (IREE'S UNCLE); OMA RICE (IREE'S MOTHER); UPPER; MILTON RICE (IREE'S GRANDFATHER), IRA (FATHER), GRANVILLE
AND JASPER (UNCLES); LOWER: CLARK AND BENDREW COLLINGS (IREE'S UNCLE AND NEPHEW); OMA AND IRA RICE AND JOAN (IREE'S PARENTS AND THEIR GRANDCHILD);
UPPER; SALLY WEST'S FAMILY (IREE'S GREAT-AUNT); LOWER: NERI AND ANDREW COLLINGS.

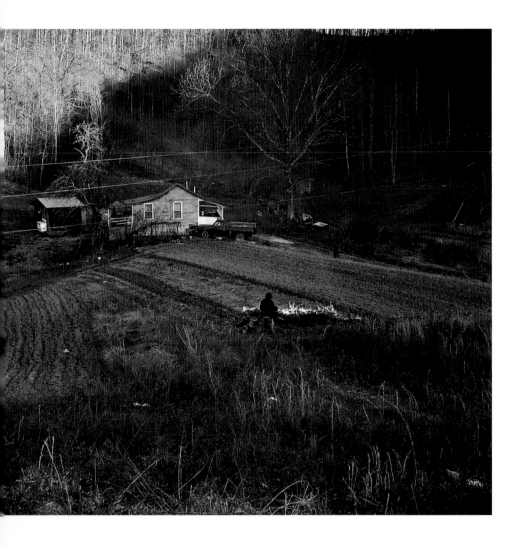

BURNING THE FIELD IN FRONT OF IREE'S HOUSE. A YEARLY RITUAL BEFORE PLANTING, FIRE REVITALIZES THE SOIL.

"You can have your cow to get milk, you can raise your own garden, grow corn to make bread, your own cane to make molasses, your own apples to make jelly."

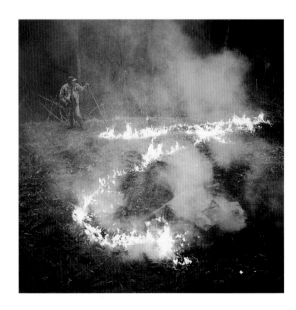

get on up in the holler. You could ride a mule or drag a sled, or walk. People survived, had their horses and mules, their cows and their hogs. Had their own pork put away. People didn't have to buy anything but salt, sugar, and coffee. Raised everything else. But you didn't get no flour biscuits or muffins, you got cornbread. And Mommy and Daddy wouldn't allow me to cook, afraid I'd use too much grease or salt. If I made a mistake there would have been a pan of bread to throw away.

When I was a child, Daddy worked on the WPA. He would have to get up at three o'clock in the morning in order to walk all the way to Chavies. I remember it well 'cause I'd get up and eat breakfast with Daddy and then I'd go back to bed. He and all the men around here went to work on the road, and they dug the road with their sweat and their picks and their shovels. (They didn't have bulldozers and things back then.)

After that, Daddy had no more jobs. Just cows to milk, hogs to kill, chickens to lay eggs. So that was it, all through the years of my life. You worked to provide for your own. No more schooling after third grade for me 'cause I had to take care of the babies while Mommy and Daddy worked.

If I would have left home for any reason, be it school or work, Mommy and Daddy would have had no help. And when Daddy died I had to take care of Mommy. I've took care of Mommy for fourteen years now. They say the Lord has a plan for everyone. I don't know, but that He had a rough one for me.

———————

I was raised up in an abusive home. Daddy would beat Mommy and pull her hair and kick her 'til I'd think she was going to die. He'd scream and holler and say he wished he had never laid eyes on her. Then he'd jump on us kids and we'd have to run outside and leave Mommy alone with him. Sometimes I'd be so scared to move, I'd just cry my eyes out.

See, you don't have to be beat to be abused—you just have to see someone in the family be beat, like your mom. He didn't beat us children, it was just what he done to Mommy that kept us all tore up inside. We were scared for him to come home, we were afraid of what he'd say. We were even scared to leave home and go to school—afraid of what he'd do to Mommy before we got back.

One time Mommy was out picking apples. She about had all her apples picked up to come back to the house, and the basket was well full. But then supposedly she fell and hurt her back Things happen in families that ain't to be told. I seen Daddy hit Mommy

with his fist and with rocks and sticks. She'd be crying, "Honey, don't hit me, don't hit me, honey." If it had been me, I would be hitting him right back. But Mommy took his abusing right on and on. So Daddy just abused her any way he could—until I got big enough to take things away from him.

I don't know if there was a lot of other abuse that went on around here back then. Could have been, but we didn't mix much. Daddy wouldn't let us go to Sunday school, and wouldn't let us go to church. I had to stay right at home. I never went nowheres but home until I got married and left. But I'd guess there was other abuse—people kept things hidden them days, in our house, too. Why Daddy could be as violent as violent could be and then when somebody come up to the house he'd be as calm as a baby. It was like he had split personalities. And all the while, I'd be so ashamed I couldn't hold my head up.

When I turned eighteen I couldn't take it no longer. I told Daddy I was going to marry and leave home. That was the only time he ever hit me. He hit me in the head with a stick of wood. He didn't want me to leave home, just because he was afraid he'd lose his big help, especially my tending to the kids. Bass's mother, Annie, doctored my sore up, cut the hair from around it. And Daddy never got to hit me no more 'cause I did what I said and got married.

And I told Daddy, "If I ever marry a man that treats me like you've treated Mommy, I'll leave him." And I meant it. And he said right back, "You'll get a man that treats you like a dog. He'll beat you to death, starve you to death, run around on you." I said, "No he won't either." And then I left.

Bascum and me, we went together for eight months and then got married, and we've never separated in fifty years—never even been away from one another but for a few days at a time. And next month is our fiftieth wedding anniversary. Feels as if we'd been married yesterday. Same love as the day we got married fifty years ago. Ain't no difference in that. We made a life on our own; nobody else did it for us. And I think we've had a pretty good marriage.

And I can say I ain't never been beat on. No, I ain't never been treated bad by Bascum.

I've been here a long time, I was born right here and I've lived right around here for about sixty-eight years. I ain't found no better place to live.

Me and Bascum work every summer to make a big garden and have our food provided for the winter— enough food to provide for the family, too. It ain't hard for us to live here. Only if you have to get out in the wintertime you can't go nowhere. The roads are slick and they don't clean the snow and ice off. So we stay in 'til the snow melts and the roads are clear and try to have everything ready for when there comes a bad spell— enough medicine, food, and all.

But there's always been plenty of land around to clean up and plant. You can raise your own beef, your own pork, your own chickens to lay eggs. You can have your cow to get milk, you can raise your own garden, grow corn to make bread, your own cane to make molasses, your own apples to make jelly.

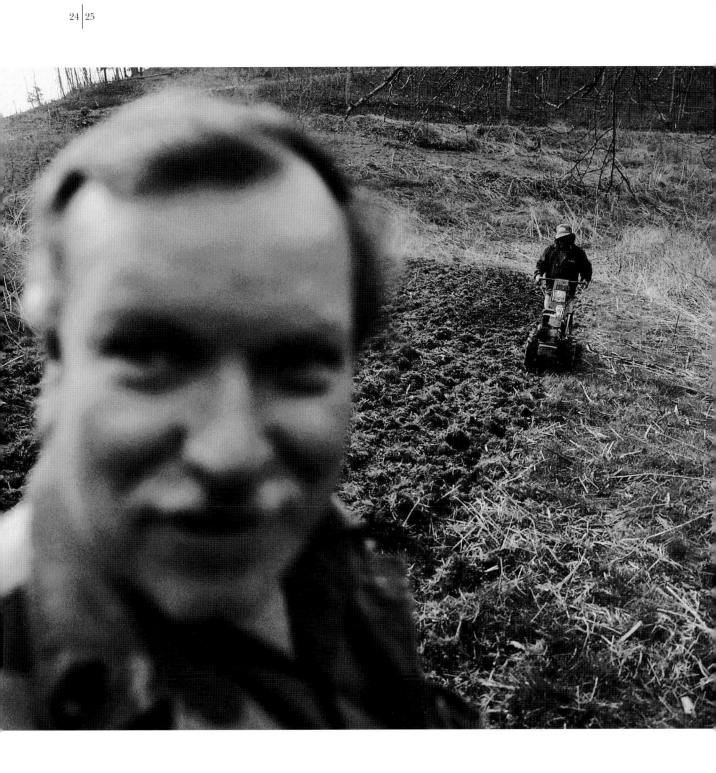

LONZO BOWLING AND HIS BROTHER
PAT BOWLING (BACKGROUND)
BEGIN TO TILL THE FIELD.

Used to be, Mommy and Daddy would go dig roots for about four cents a pound. Now Lonzo and some of the boys collect bloodroot, ginseng, and moss. Takes a lotta roots, when they're dried out, to make a pound. Back then, we'd all go to the cliffs—catch birds, ground squirrels and skin them, clean them up, broil and eat them. Now, we've had hard times and we've had good times and we've had sad times, but we've had more good times than bad.

I sure ain't poor. I got a place to lay my head, food to eat, bed to sleep in, clean clothes to wear. If somebody ain't got nothing to eat and no place to sleep, no home, that's poor to me. Wouldn't you think that? That's why when I see these little kids on TV with their little stomachs puffed out, their little skinny legs and arms, I wish I could bring them here and teach them how to work. We'd all get over on that hill and cut those bushes down, start digging in corn and beans.

I think I'll spend the rest of my life on the top of this hill. Why, I love doing what I do, making a garden. I love canning food, I love drying it, I love eating it, too—I enjoy eating it most of all.

Me and Bascum might have worked hard, but now that didn't hurt us. I'm sixty-eight, he's sixty-nine, and we're still working. And I plan on working as long as my hands will move and my legs will go. No, I don't consider myself poor—never did. I feel like I'm rich, rich as the Lord wants me to be.

———————

I've been fortunate to raise thirteen children and live here and teach them how to work and what to do. I feel like I'm doing a good job. And I can say nobody ever went hungry and nobody went without clothes and nobody went without a home to stay in, even if that home ain't always been the finest.

PAT TAKES A
CIGARETTE BREAK.

EDITH MOTLEY, PAT'S
GIRLFRIEND, CLEARS OFF
LOCUST TREES.

When we started out, Bascum and me we didn't
have everything we needed, but we still made it—we
stayed well and able to do for ourselves. Most people
can't say that. When you are grown up and you take a
wife or husband, you're on your own to make life good
or bad. Mommy used to tell me, "You make a rough
bed, you have to lay on it." Well, we made a life on our
own, nobody else did it for us.

After we married, Bass and I moved to Clay
County. Now Bass didn't go along to work by himself;
I worked at a stave mill with him. We made staves to
make barrels out of, make whiskey barrels. I stripped
them at the mill and I stacked staves and hauled
sawdust with mules away from the mill. I done all kinds
of work up there. And Bass's mom would tend to the
children, the ones we had then. We stayed out there in
Clay County about five years, then Bass's mother passed
away, and then his dad was killed. Bass's dad was named
Green Bowling, and a man shot and killed him in his
own home and then left him to die. They was playing
cards and Green was winning; then this fella just got up
and shot him. Green's buried over there in Clay County.
After he got killed, Bass sold his part of his daddy's
estate for 1,350 dollars. With that money, we bought
four acres from my daddy, right down yonder, and we
built us a house in the holler.

Oh, it ain't been easy, but we survived. Our house
burned up once and we lost everything. It was about
eight o'clock in the morning. I had just got all the kids
out of bed and was fixing them breakfast. I had five kids
then. I left the stove a-burning, a cooking stove, and

"Used to be Mommy and Daddy would go dig roots for about four cents a pound. Now Lonzo and some of the boys collect bloodroot, ginseng and moss."

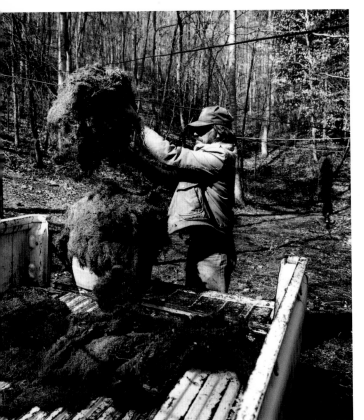

it caught from the pot, the ceiling did, and when I opened the door to take the children in there—Lord, that end of the house was burning down. I told the young'uns to run to the barn, to run to the road where the barn's at and get in it. And I got the baby, and grabbed a quilt there was on the bed and a pillow, wrapped the baby up, and went to the barn. I thought I might get other stuff out of the house but it was burning so fast, that old pine lumber.

I just watched everything I had burn up. I had all my canned stuff put in this closet in the house, and you could hear them cans a-busting and see all the seasoning go up in smoke. It all went up in smoke and all my quilts that I had made, I had twenty-nine new quilts made and they all went up. We had just one old dishpan and a blanket left.

We stayed in the barn that day and part of the night and then Daddy come to us. And we stayed with him until we found a place to go. Then Bass's cousin told him, "I got a two-room building, you can move in it." I was so tickled. It wasn't no account, but a roof and a place to get dry and to stay warm. It did us fine for the time being.

People give us food, clothing, pots and pans. Whatever we needed, quilts and blankets—all the neighbors did so to help us back to where we could

STEVIE BOWLING SORTS THE MOSS HE
HAS GATHERED. THE MOSS WILL BE
USED AS DECORATION BY FLORISTS
THROUGHOUT THE COUNTRY.

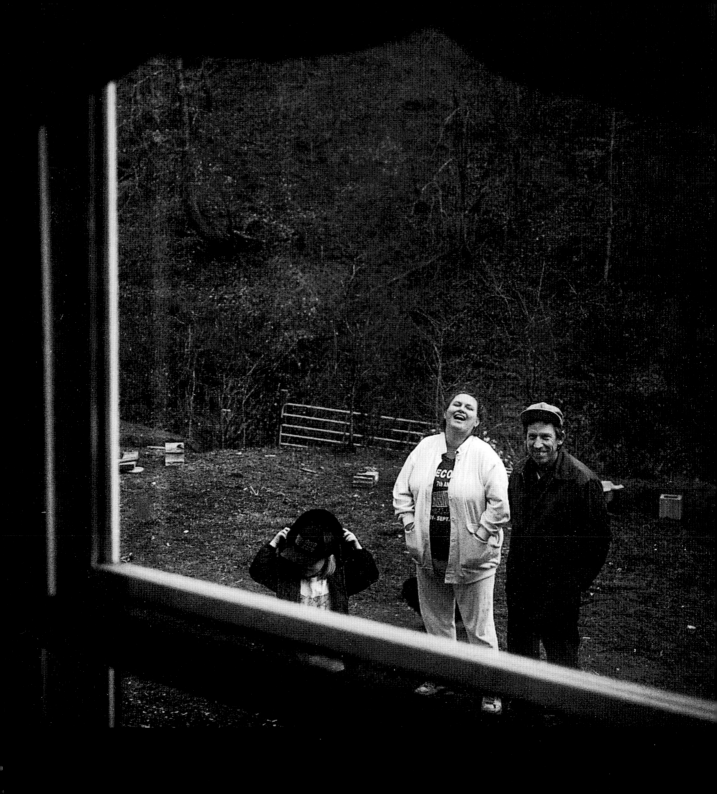

RITA AND EDGAR BOWLING AND
THEIR DAUGHTER BRITTANY, AGE
FIVE, OUTSIDE THE FAMILY TRAILER.

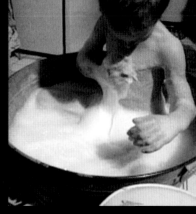

JEREMY BOWLING TAKES A NIGHTLY BATH IN
THE FAMILY'S RINSE TUB. HIS HOUSE IS STILL
WITHOUT A BATH, SHOWER, OR COMMODE,
THOUGH HIS PARENTS, NEIAL AND WANDA,
HAVE JUST PUT IN RUNNING WATER.

EVERY LABOR DAY, IREE HOSTS A HOME-
COMING CELEBRATION. NEARLY EIGHTY
FAMILY MEMBERS ATTEND, MANY
RETURNING TO THE HOLLOW FROM
OHIO, FLORIDA, AND OTHER STATES.

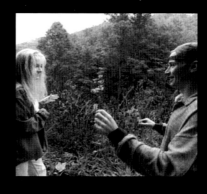

CLINT BOWLING AT AGE
EIGHTEEN, THEN PLANNING TO
WED HIS SIXTEEN-YEAR OLD
SWEETHEART SHIRLEY COUCH.

TO SUPPLEMENT THEIR WELFARE
CHECK WITH ADDITIONAL CASH,
MANY OF THE BOWLING BOYS SELL
ROOTS AND MOSS GATHERED
FROM THE SURROUNDING HILLS.

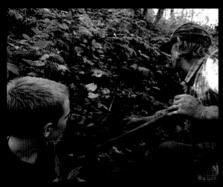

IREE HORSING AROUND IN THE KITCHEN
WITH LISA RAISOR, EDITH MOTLEY'S
DAUGHTER; IREE'S SENSE OF FUN AND
PLAYFULNESS NEVER DESERTS HER.

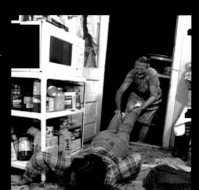

IREE IS BLESSED BY THE REVEREND AT
THE PENTECOSTAL CHURCH OF GOD.

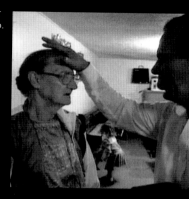

ENRAGED BY HIS WIFE'S DECISION TO LEAVE
HIM, JOE CANADA DESTROYED THE FAMILY
TRAILER. HERE, A FRIGHTENED SAMANTHA
ASSESSES THE DAMAGE TO HER LIVING ROOM.

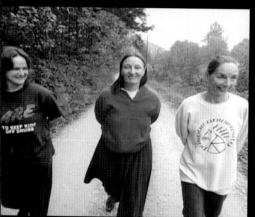

WANDA JOHNSON, BETTY RICH, AND POLLY
DEAN, SISTERS FROM A FAMILY IN CINCINNATI,
EACH MARRIED ONE OF IREE'S SONS, AND
NOW RAISE THEIR FAMILIES IN THE HOLLOW.

IN A CASE OF MISTAKEN IDENTITY, EDGAR
BOWLING HAS BEEN ARRESTED FOR TRESPASSING
AND IS NOW BEING HELD IN THE COUNTY JAIL.
HIS BROTHER NEIAL, VISITING, PROVED UNSUC-
CESSFUL IN RAISING THE $2,500 FOR BAIL.

POLLY BOWLING DRESSED
AS A GHOUL FOR THE ANNUAL
HALLOWEEN HAUNTED HOUSE.

MARION WILLIAMS, IREE'S SISTER, LIVES
DOWN THE ROAD IN A CABIN WITHOUT
RUNNING WATER. HERE, SHE DRAWS
WATER FROM THE WELL OUTSIDE.

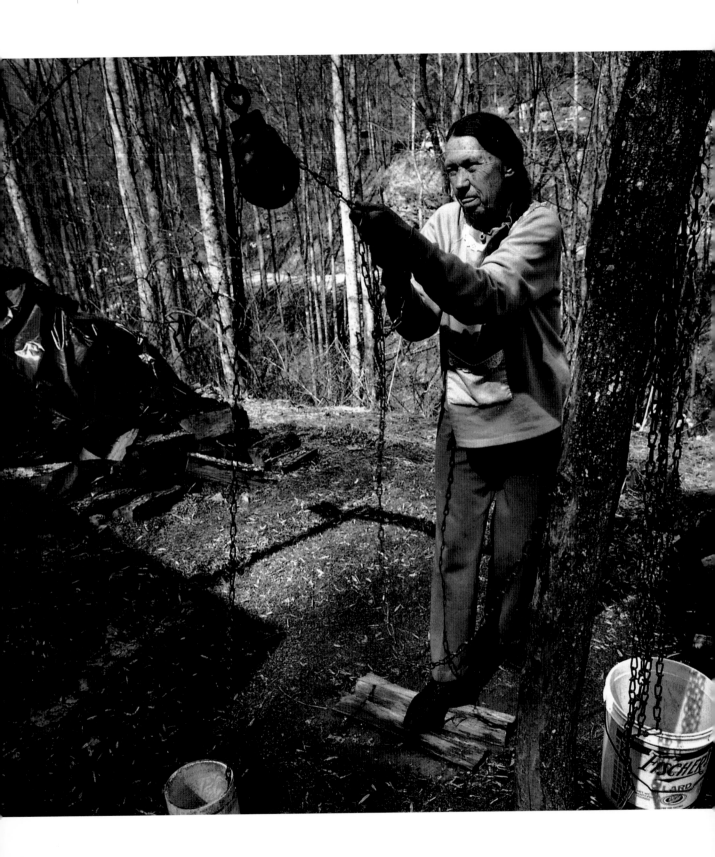

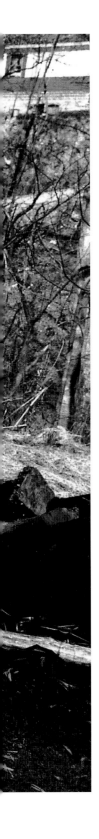

"Things happen in families that ain't to be told."

make it on our own. But we made do. I was even lucky just to save my children.

Whenever somebody's house burns up I give them dishes and quilts and blankets, whatever I've got they need. There used to be a lot of fires, though not anymore they're not. They had these old chimneys built to the sides of the houses and it was easy to set a fire. Had the cracks stopped with mud in them old log houses. Them old dried pine logs would burn fast.

We even had to go get a new marriage certificate 'cause ours was burned up in the house. We went to get a copy of it, but there was no copy on record. It turned out that the preacher that married us hadn't even turned the certificate in to the courthouse, so we ended up having to get married again. And Bass says, "We got married twice and we ain't ever even had no honeymoon!"

When we got remarried, the judge wanted Bass to adopt his own children, and wanted to charge us one hundred and fifty dollars a piece for the thirteen of them. Bass was mad alright, said "I know they're mine." The sheriff was standing there right beside us, said to the judge, "Man don't have to adopt his own children—you crazy to talk like that." And so we just walked right out of the courtroom.

This year on our wedding anniversary, Bass's sister and brother-in-law are coming down. They're gonna take us to dinner, to the Ponderosa. You won't believe I've been with this rascal fifty years. I broke the record. And it's been a good marriage. We ain't never been fighting, scratching, or tearing one another up. And Bass ain't hurt me in no way; he ain't abused me in no way. He helps me do the work. Whatever I do, he does it, too—except cooking. He don't cook none.

"Bible says if you don't provide for your own, you've denied the faith even worse than an infidel. That means you ain't no account at all."

My baby sister, Marion, lives down the road. She's retarded. What it is, she believes things happen that don't: she hears things and sees things that aren't real. But she lives by herself and has for twenty-nine years.

When she was a little girl there was a big old mulberry tree up on this hill. Arthur Barger (he was a neighbor of ours at the time) was shaking some mulberries off. Marion was under the tree and a rock fell out of the tree where somebody had throwed it up before to knock mulberries off and it had lodged. And when Arthur shook the tree the rock fell out on Marion, hit her smack on top of the head, and knocked her out. That about killed her. And we never did take her to a doctor—in fact, we didn't even know what a doctor could do for her. But after that, Marion was never right again. She was queer, sometimes wild. She'd get into fights with the refrigerator, with the stove, the sink—just tear 'em up. She is something else, my baby sister.

When Marion's husband Claiborne was alive, he treated her real bad. Lord have mercy, he treated her in ways he ought to have been killed for. If Daddy had known, he'd a gone right into the house and killed him. You see, Claiborne had a stick he kept behind the door and he called it Old Hector. And that's all Marion ever talked about, Old Hector. "Old Hector is awaiting when I get home." And kept on saying that, kept on and on and on. Ain't nobody thought about him hitting her, but Claiborne beat her with that stick. And even after that, Marion'd say that he loved her. Why, she'd have bruises all over her body and let on to Mommy like she fell down.

But the truth comes out, in strange ways maybe. Marion's daughter, Joanie, would constantly scratch herself, scratch at her legs and her arms 'til they was a running sore. It might a been her nerves over her mother that was causing it, was what it was. She was afraid her dad was gonna kill her mom. Joanie said her dad beat Marion just about to death and done her in ways that aren't nice to talk about. In fact, Joanie told me last summer, "Iree" she said, "if Daddy was living today, he'd be a dead man. I'd kill him for what he did to Mommy." So I suppose it's a good thing he's dead now; he died a while back.

Back then, I lived down there at the foot of the hill: me and Bass and our children. Marion would come visit and sit down beside the stove trying to get warm. I'd say, "Marion, I want to know what's wrong with you. Why you acting this way?" She said, "Did anybody ever say anything to you, did Claiborne ever tell you that he could drink blood from your body?" I said, "No, and he sure won't be a doing it, either.

MARION AT HER CABIN DOOR.

"Back then we'd all go to the cliffs—catch birds, ground squirrels and skin them, clean them up, broil them and eat them."

THE CLIFFS WHERE GENERATIONS OF BOWLINGS
HAVE PLAYED HIDE-AND-SEEK, HUNTED BIRDS,
AND TAKEN REFUGE FROM THE SUMMER STORMS.

Don't you think that Bass and these boys would kill him over me?" But all Claiborne was doing was aggravating her. 'Cause he'd a been afraid to pick up a gun and shoot. He knew Daddy and the boys would have killed him, no doubt. If they knew what he was up to, they would have got Marion out and burned him up in his own house.

One day Daddy asked Claiborne, "I want to know what Old Hector is." Claiborne said that it was his walking stick that he'd use to go out into the hills to work, to dig ginseng. And then Daddy warned him: "Now, that Old Hector better not be beating on one of my young'uns. I'll be checking on it."

Then I told Daddy that Claiborne had beat Marion and right away Daddy made him leave the hollow. Daddy just picked up his gun and shot right over at the house. And Claiborne left and he never came back. Daddy yelled at him, "You better not come back, I'm going to kill you if you do."

See, I'd say there's less abuse now than back then because before there was no way to call the law up here. And I'd say men like Claiborne are afraid of the law being cut on 'em. Besides I don't think that women would take it anymore.

Claiborne eventually died of cancer. He stayed in the hospital in Peabody when he was dying and me and Bass went over to check up on him. The doctor said his liver was all eaten up with cancer, said you couldn't lay your finger down where there wasn't a spot. Claiborne said he wanted to see Marion and Joanie. I come back and told her, but Marion just said straight out, "I ain't going to go see him." And she didn't. She wouldn't even go to his funeral, and she wouldn't even take her little girl.

I had to cook food for Marion this past winter to keep her from starving to death, and build fires for her to keep her from freezing to death. Marion is capable of getting in wood and coal, but she got sick and wouldn't build herself a fire. I'd go out there and she'd say, "My nose is froze off, my nose is froze off." I said, "Old girl, why ain't you building a fire?" "Won't burn," she'd tell me. "Well, it won't burn if you don't put something in it to burn," I told her. "If you can't take care of yourself, I'm putting you in a nursing home." That straightened her up. She knew I'd do it. 'Cause there wasn't no way I could run back and forth to her house, when the snow was up to my knees on the side of that hill. I bought her a brand new stove and she said, "It won't cook." I said, "Sure, it won't cook if you don't turn it on." But after a while Marion straightened up— now she raises a garden, cans her own beans, grows cabbage.

If I get to where I can't take care of myself, I don't know what's going to happen to the others. Marion's daughter, Joanie, won't keep her and I sure can't take care of her. I can't tend to Mommy and do for Bass and myself and come out here to take care of Marion. Joanie hasn't even visited since last fall. Joanie don't write Marion, she don't call her no more.

Marion gets sad and says, "My young'un don't love me no more." And she ain't got but the one, that's Joanie. She says, "I don't want to live, I just want to die."

Bible says if you don't provide for your own, you've denied the faith even worse than an infidel. That means you ain't no account at all and I'd just hate to be that kind of person. So Bascum and me decided we'd work to make this garden as long as we was able, even just the little garden. This way we'd just fix ourselves something to have always fresh to eat come the summertime.

The doctors told me that they didn't want me doing too much standing up and hard work, that if I kept on like I was doing then it wouldn't be long before I was in a wheelchair or in a walker—or both. But gardening's always been easy. First, you get your ground ready. Put your seed in the ground, then your plants, then your fertilizer. You plow it, and you put fresh dirt around when the roots come up to get them started out growing. Then you put your dust on, that's to kill the bugs and worms off. When the garden is too big to work around, then you just lay back and let it make itself. All's left is to take the vegetables off and clean them.

Break the beans and put them in your jars, cook 'em for four hours. Take your cabbage down, clean 'em, chop them up and make your kraut. Tomatoes? You take them off the vine when they get ripe, can them, or put them in the freezer. From one thing to another, just like that.

Sure, it's work—but I can fill a hundred cans of beans a day. And we've got four freezers practically full. We got corn here that we shill and take to the mill to make bread, and to ground for cornmeal. That big bunch of green stuff is rhubarb, to make pies. Cabbage is over yonder, that silvery bit at the edge.

We use about everything we grow in the garden. We got our peas already come up. Our 'taters planted. Lettuce sowed. Beets sowed. There's not many people that do like we do, that get out and work in the garden anymore. And I don't think nobody will never take care of this land like I have—it's passing and it's a shame, for there's something good in it.

CLINT BOWLING AND HIS YOUNGER
BROTHER JOSH HUNT SQUIRREL.

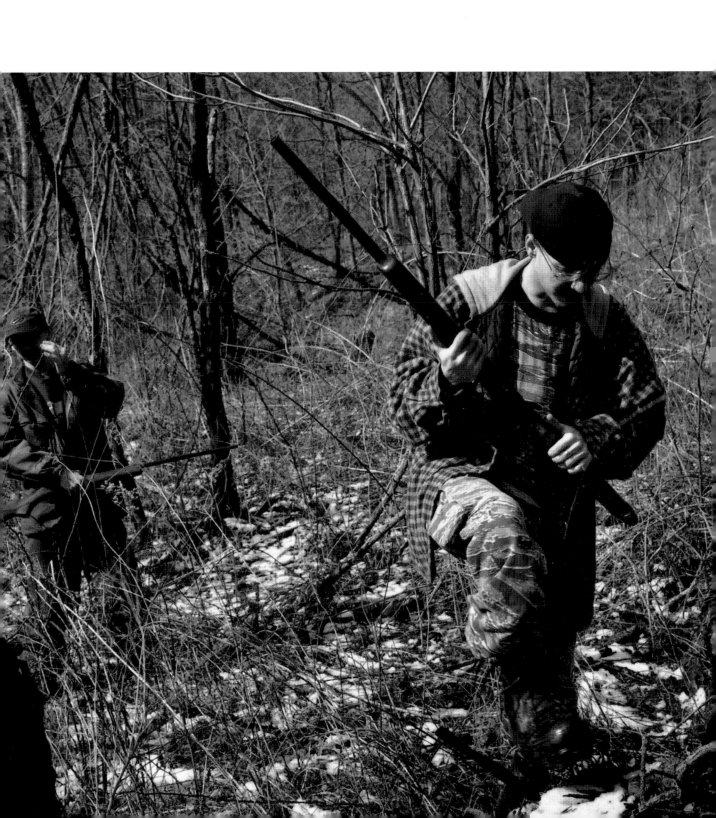

IN SUCH A REMOTE AREA, CARS ARE
ESSENTIAL. DURING THE WINTER, A FOUR-
WHEEL DRIVE IS NECESSARY AND WHEN
THE SNOW IS HEAVY EVEN THAT WON'T DO.

But you should come down and watch me can food. Whenever the beans go to getting full. And I wish
you coulda watched us drying cane and making molasses. We used to do that all the time. I'd like to do it this
year, but I doubt I will. I'd have to be the one skimming the molasses and, well, the doctor don't want me
working that hard.

———————

If you want to make a life for yourself you can, it's up to you. The young generation just don't care much,
they're grown up not to care. There is too much stuff going on for young people. They should stay out of
trouble and be at home with family instead of out running the roads. Now that is true. They should be home
with their family.

We taught our children to work, raised 'em to do for themselves. They didn't argue back; they done
their chores. If they didn't, I switched them—not a club or a big tree limb, mind you, just a switch, a little one.
I tried my best to be a good mother. And Bass never drank at home and he never beat on his young'uns. I
cooked three meals a day for my children; they came home from school every day to supper on the table.

All my kids went to Sunday school. I don't get to go to church now. Since I been taking care of Mommy,
I've went maybe a half a dozen times. But before that I went every weekend and all through the week. I'd go
on Friday night and Saturday night and Sunday night and Wednesday night. I took all the children with me. It
was a big church house. I guess it'd hold fifty or a hundred people. Pentecostal Church of God.

See the Bible reads about the church of God. If we don't believe in God then I'm afraid we'll be lost. The
family all believes the same way, they all go to the same church. Still, the boys They gamble.

To lose most of your money in a game? They usually lose more than they make. I've been in hard places,
but never got hard enough to fool with that stuff, or to raise pot plants, or nothing. You got to watch where
you go and what you do. It is even dangerous to get out into these hills ginseng-ing. I tell all these boys, you
better watch it, you'll be walking up close to an old pot patch and somebody will shoot you dead. It has been
done all right.

David was in jail. Neial too, but Neial didn't have to stay long. David had to stay a good while. I told him he would get in trouble. And sure enough, once he got into jail he wanted out, alright. After five months they sent him to Johnson County for community service work and he stayed there all summer. When the weeds and all had died, they sent him back to Blackburn and he stayed there until May 2. Then he got to come home permanently; they just let him out, turned him loose.

He'd only stayed in two years out of the five. Supposed to stay five, but I guess the prayers that went up for him brought him home—a lot of people prayed for him. And David ain't been in no kind of trouble since. He got his own garage and his own car lot and lives in Cincinnati, Ohio. He don't like it down here in Kentucky anymore, and he don't ever come back unless he has to.

Right now, they got Edgar in jail. I hate to see him over there, but he'll get out. He has never been in no kind of trouble, never been in no kind of trouble like this before. He was accused of breaking and entering property. The man says there was trespassing signs there. Edgar was out ginseng-ing and said there were

"In the wintertime you can't go nowhere. So we stay in 'til the snow melts and the roads are clear and try to have everything ready for when there comes a bad spell, enough medicine, food, and all."

no signs put up nowheres. I ain't got no trespassing signs put up on my place. Anyone can come on to my place who wants to, ain't nothing I can do. Edgar said the man took his name and truck tags and got a warrant. But Edgar did not break no locks, he did not go through no fence. He came down by the barn and met the man and said he had nothing to hide from him.

And nobody didn't see Edgar with nothing, didn't see him break no locks. But he's accused of breaking and entering. He'll just have to stay in jail is all. When you got to, you got to, but I'm praying in my heart somebody will get him out.

———————

Barbara, Pierce, Ivalene, Steve, Lonzo, Edgar, Dennie, Thelma, Neial, Pat, Becky, Ruthie, David: I've got thirteen children. My baby boy is David. He was born the thirteenth day of April and he's the baby, my thirteenth child. I didn't want that many, but I got that many. I wouldn't give a nickel for a dozen now.

We all lived in this house together at one time. Back then there wasn't a window, and there wasn't a door on the house. There wasn't a ceiling, and there weren't hardly no partitions. Eight boys from eighteen on down stayed in the one room with two beds. In the girls' room, five stayed—there was one big bed and a little cot. And Bass and me had a little bed in our room for the babies. Babies were in with us 'til they got big enough to go to school.

The living room had an old couch, a TV, and a big old wood stove. We kept one bed in the living room for babies to sleep in during the day. The young'uns all ate at the table at the same time. Now in our kitchen we used a wood and coal cooking stove, didn't have no electric stove. The bathroom was outside. Didn't have no well, so to cook we carried our water from the spring way out yonder. Got our wash water from up out from under the hill.

The hardest thing was keeping wood and coal. Because if you don't have a place to get your own wood, then you have to buy it. And coal you always have to buy. But working and making gardens and canning, all that comes natural to me. I never knew what an easy life was. I've had to work, manage every way that I could, from a needle to a hoe. Now that's right. But still it's a good life to live.

We don't have no trouble. But if you don't try to help yourself you ain't gonna make it. It's been like that all down through the years—when I was a little child it was work one day for what you ate the next. I remember the days and years we had everything rationed, like shoes, and food. You had to have ration

IN MUCH OF APPALACHIA EXCESSIVE CLEAR-CUTTING HAS DESPOILED WOODS.

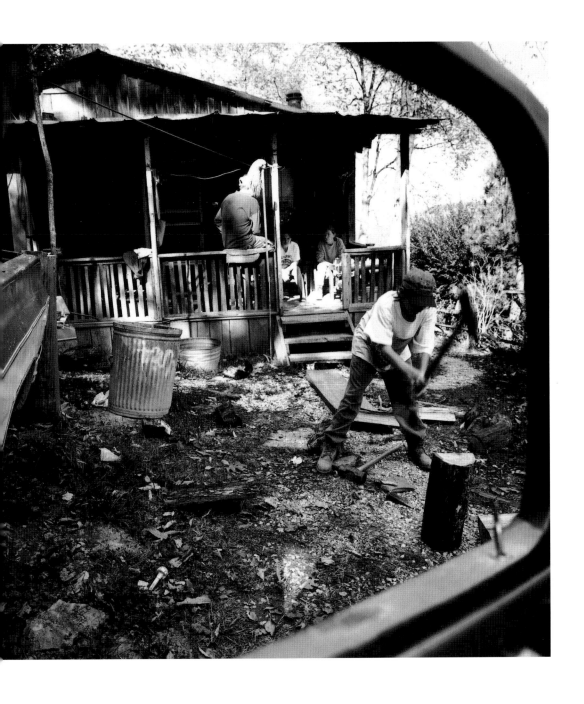

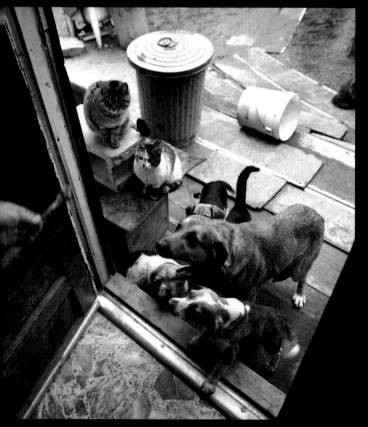

stamps. It has changed a lot now. There are better homes to live in. When I was growing up you was lucky if you could get a board roof and that you had to make yourself, even to cutting the timber out of the hills. Now they can use shingle, they can use tin.

I think we get by a lot better than folks in the city. Plenty of room to run, plenty of fresh air, pretty trees to look at, a good garden to work in. Me, the city ain't got no place for. You can't get outside and play music, play horseshoes, play ball, play marbles, play rummy without somebody ain't hollering at you. If you live downstairs the ones upstairs are gonna be hollering "Cut that noise out!" Or they'll be stomping on the floors and you'll be wanting them to hush and you'll be hollering up at them. I've been there in the city before and I like living right here, where I can do what I want to do. I'd be closed in if I moved to a city. I wouldn't know where to go.

I don't think there could be any better place for to raise children, leastways 'til they get old enough to work. Then they have to leave, 'cause there's no jobs around here. We tried to get some of them to go on to school, make something better of themselves, but except for Ruthie, they just wouldn't do it. So then people left, thought to have a better place to live and a good job to support them and their family. But it

didn't work like that. All my children are grown and
married now, and they've left home and after a time
they've come back. When you work at minimum wages
and you have to pay high rent and you have to buy
everything to eat, you ain't gonna have nothing to live
on. So they come back home, to a life where you can
have a roof over your head and you can raise some-
thing to eat.

All of them come back here. All my children
(except for David) live within an hour's drive away
from us. My daughters left home, too, and even they've
come back. Neial left twice and come back. Lonzo's
left I don't know how many times and come back—with
both his marriages. Dennie left and he married Betty
and then come back. Pat, he went out to Ohio and
stayed a while and then come back. He said, "I'll never
be that far away from home no more on Christmas,"
and he's been home every Christmas since. Stevie left
and got married, then came back.

Different things brought them back—work for
some. Pierce left home to work at Norwood, Ohio,
a Chevrolet plant that made cars and stuff—worked

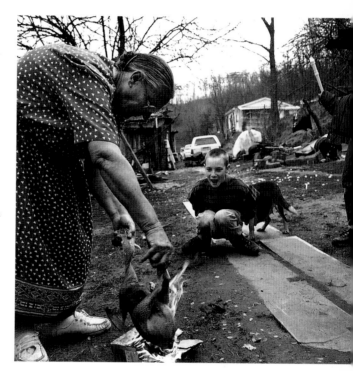

ABOVE: IREE RAISES,
KILLS, AND COOKS HER
OWN CHICKENS AND PIGS.

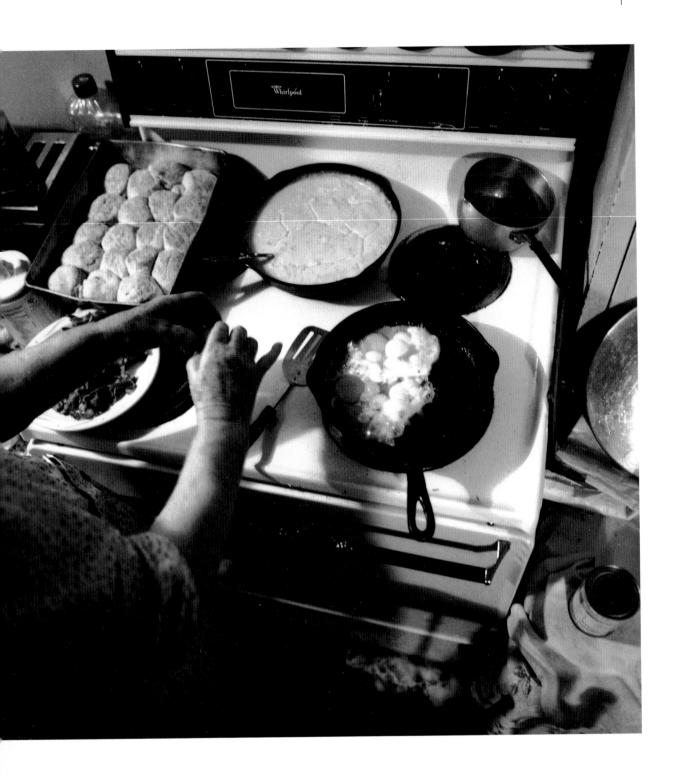

ABOVE: BAKING
HOMEMADE BISCUITS.

THE FARM FULFILLS MOST OF IREE'S
FAMILY'S NEEDS, BUT NOT ALL OF THEM.
OVERLEAF: BASS AT THE SUPPER TABLE.

"Bass helps me do the work. Whatever I do, he does it, too. Except cooking. He don't cook none."

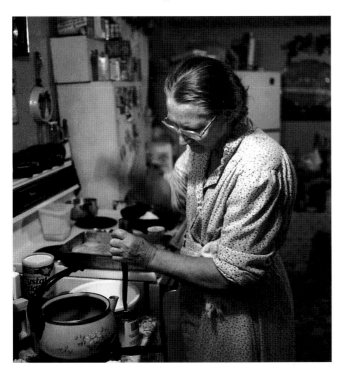

there eighteen years. And then he come back home after the company moved to another state. He wouldn't go with them, so he came back home. He built a house; his son lives in the house now and Pierce bought a trailer and he lives in that.

Home. I guess it's home that makes them come back. Stevie and Penny got married, then he lost his job and they come back here to live. They knew if they was home they wouldn't have to do without. That we always have food—we always have a place for them to stay and we take them right back in, no matter what's happened.

——————

First time Mommy started getting sick was a day in springtime when she went out into the yard and lifted up an old tin, and looked underneath at some puppies. When she raised herself back up, well, she never did get back into the house. She just fell right down on the ground. From then on Mommy got worse and worse and worse.

I've had to feed her for six years now, going on seven. Every day, three or four times a day. She don't

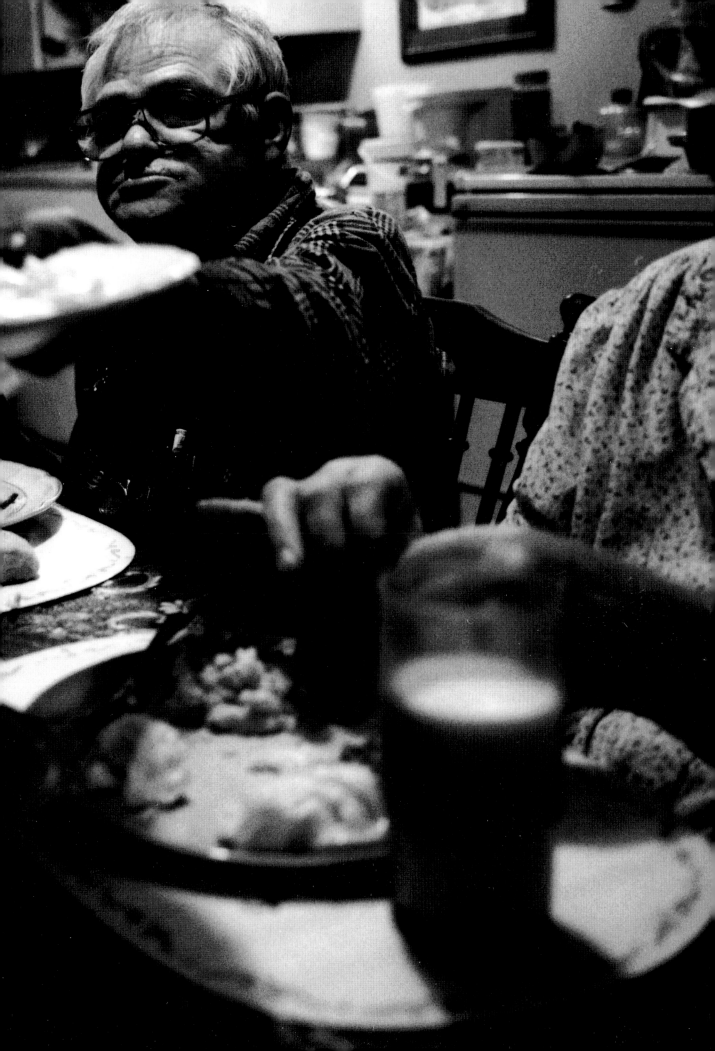

IREE CARES FOR HER MOTHER, OMA
RICE, AGE NINETY, WHO HAS BEEN
BEDRIDDEN FOR THE LAST SIX YEARS.

seem to mind the company, nothing bothers her that you can tell. At times she won't pay any attention to me. Some days I get so tired myself I don't feel like standing and feeding her, but even so, I don't mind feeding her. She fed me when I was a baby, otherwise I wouldn't be here. And I know I could never have gone through what Mommy suffered, with Daddy beating and abusing Mommy from the time I was a little bitty thing until after I was married and gone. Not me. She had a hard time of it.

We have a nurse's aide that bathes Mommy once a day, five days a week, but they took some home health-care away from her. She don't get no aide help no more on the weekends. And now I have to buy her bed pads and her supplies if she gets any. And boxes of that stuff costs me forty dollars to sixty a box. It was something the governor has stopped them from paying for. But she's just laying there and I have to do all I can for her. I'm thinking about writing the governor a letter and asking him why they are cutting home health-care out. Why when there's so many elder people that need to stay home instead of going to a nursing home?

I've been in them nursing homes. We visit the nursing homes, me and Bass go and visit people. It tickles them so good to see us come. But I sure wouldn't want my mother to stay there 'cause they lay in bed wet and don't get enough to eat. The nurses just go through there, check them, and go on. If they don't eat, the nurses just take their tray back and throw it

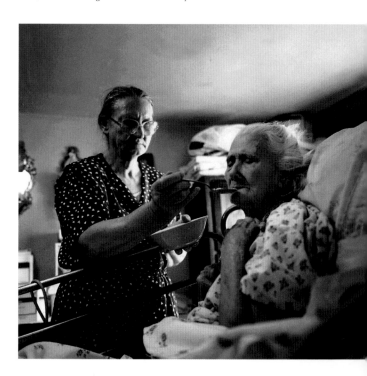

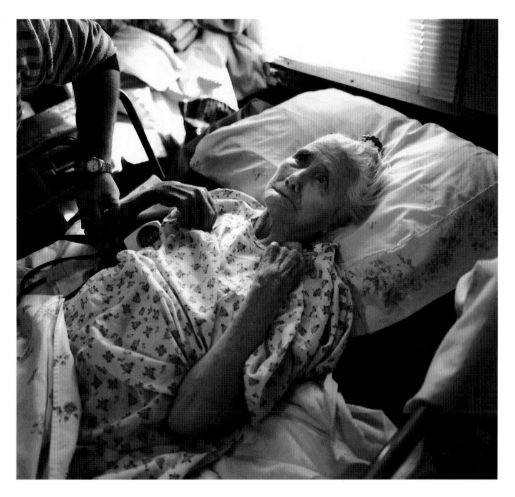

"I don't mind feeding her. She fed me when I was a baby, otherwise I wouldn't be here."

out. But it takes more than an hour to feed an old person, 'cause old people eat slow.

Still, we have the nurse that will come out here and check on Mommy every weekday. They come from Hyden Home Health Center, about thirty miles from here, so they're about a sixty-mile round trip.

It is a help. They take her blood pressure, check her bones and her heart and her legs and arms to see if she's got the pulse still beating in them. And they check me because I'm diabetic. I have to take diabetic medicine and heart pills with dinner.

I've only been a diabetic, I guess, for close to a year now. For Bass it's been about eight years, I guess, or longer. No, Bass has been diabetic for about fifteen years. His grandma was and then his dad, and then him and our daughter all are diabetic. He takes shots.
I take the pills.

OMA GETS A CHECK-UP
FROM THE VISITING NURSE.

BOTH IREE AND BASS HAVE DIABETES AS WELL AS
A NUMBER OF OTHER HEALTH PROBLEMS. HERE,
A HEALTH AIDE TAKES BLOOD FROM IREE.

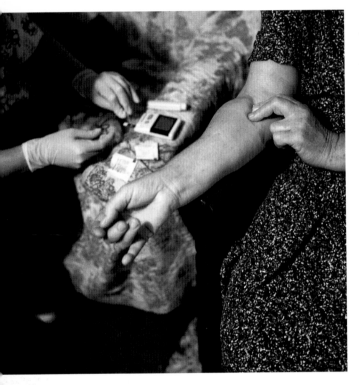

All we know about Mommy is that she's got Alzheimer's and a stroke. For six years she's been like a baby. I diaper her, feed her, and she just lays there. Any other way she'd be in a nursing home. And I ain't against a nursing home; it's the best place for folks that has nobody to take care of them. But I wouldn't leave Mommy for no amount of money. She's got no other girls, and no daughter-in-laws helps take care of her, excepting Edith, Pat's girlfriend. Mommy always said that if any of her children took care of her, she wanted it to be me.

———

See, I try to take care of other people and leave myself out. I told you the reason I wouldn't go to the doctor: I'm afraid to. I'm afraid he'll tell me something bad is wrong. I ain't the wellest person in the world, but I ain't the sickest either. I could tell you a long story about things that have happened in the family when people have gone to the doctor—I mean what's happened afterwards.

I know that my loss of weight and this throwing up, that ain't a good thing. I'm not even throwing up

"I ain't the wellest person in the world, but I ain't the sickest either."

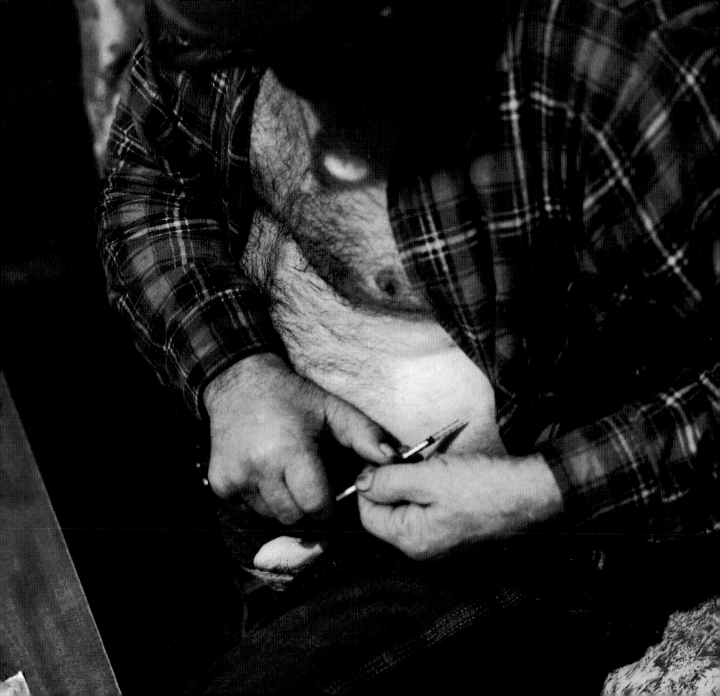

Jasper, the first one, his toes come off with sugar, diabetes. And then they x-rayed him and diagnosed him for cancer of the stomach. They told him if he had anything in his life to set right it was time he better be doing it. And about three months later he was gone. Then the second one, Daddy's sister, she got sick. They done the same thing, diagnosed her and she had cancer. Then another uncle, Granville, he had cancer. He went to the doctor and didn't last no time 'til he died. And Aunt Milda had a big old knot come on the side of her neck, and when they took it off and looked at it, sure enough it was cancer. She just lived a few weeks after that. And Aunt Dosha, she had a big mole, a birthmark on her arm, and it was cancer when they took it off.

But I ain't too worried about being sick. What's gonna be will be, no stopping it. There might be things the doctor can prolong—remission, you know, make you live longer. And then the doctor could make it worse. My bones are deteriorating: they showed me in an X ray. See, I had my arm broke twice and my collar bone broke, and I sure don't want to break no bones no more.

I told the doctor how my head was bothering me. He said one of my eyes was real bad, that it failed me worse than it had the whole time he was taking care of my eyes, making my lenses. I said I couldn't pick a coffee pot up with my right hand, had to use my left. And that

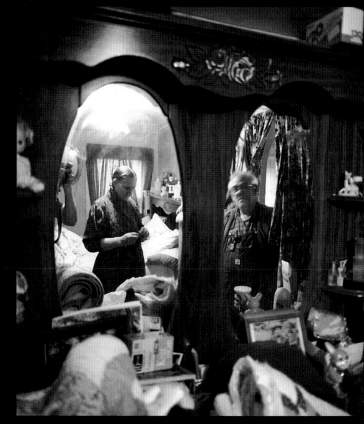

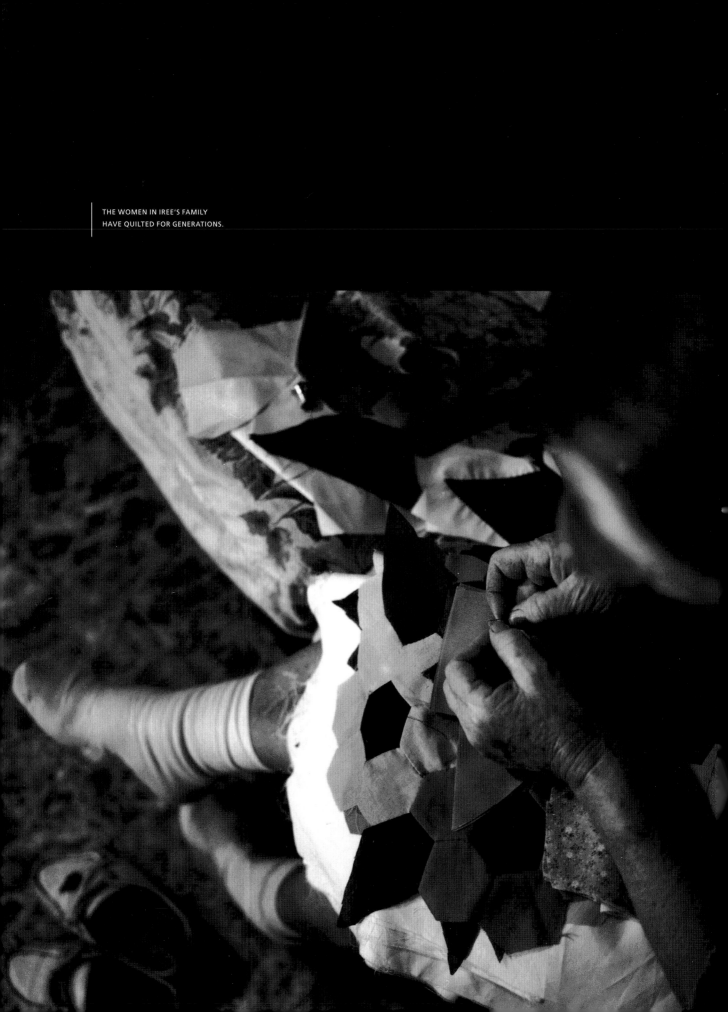

I keep falling asleep. He said I probably had a light stroke, what you call a miniature stroke. But it didn't feel too miniature—my head hurt me so bad.

I got an enlarged heart. What do you call it? An agitated heartbeat. Doctor told me I had to keep on my heart medicine. I also got high blood pressure medicine. And then I got those gallstones, too. That's what is bothering me most. The doctor, he wants to have them took out—but I won't have it.

I'm not supposed to walk down the steps without nothing to hold on to, doctor's orders. And I'm not supposed to be wearing slick-bottom shoes, doctor's orders. Not supposed to be lifting heavy loads, either. But I can't help but keep busy.

Seems like I just can't get away from sewing, cooking, washing, doing all the things I was raised up to do. And I love doing it. A lot of people don't use their hands much and their fingers get stiff at the joints. My hands have sure been through a lot. There been many a biscuit made and many a stitch sewed. This winter I'll be sewing from the time the first cold spell comes until it's over. And I'm hoping to get four new quilts made by the time spring comes.

My great-grandmother, she wove her own blankets with sheep wool. She had a weaving mill and she made the thread, wool thread. She knitted socks and gloves and sweaters and things like that for the family. Then Grandma, she owned sheep and she done the same thing, always made her own bedcovers. And then Mommy, you know, she started quilting and so it went on and on.

I never did knit nothing. I didn't want to. I seen Mommy knit and it seemed like a pain even trying. I wouldn't do with that. But Mommy made quilts, too. And every one of the children, every one of us sewed. We'd all sew one block all together. Mommy wanted us

IREE CONTINUES A CENTURY-OLD TRADITION. COMPLEX QUILTS CAN TAKE MORE THAN A YEAR TO COMPLETE.

"My great-grandmother quilted and wove blankets from sheep wool. Then my grandmother, she done the same, quilting and making her own bedcovers. And then Mommy, she done the same. And so I'm doin' it, and then my daughter Ruthie— from generations on down."

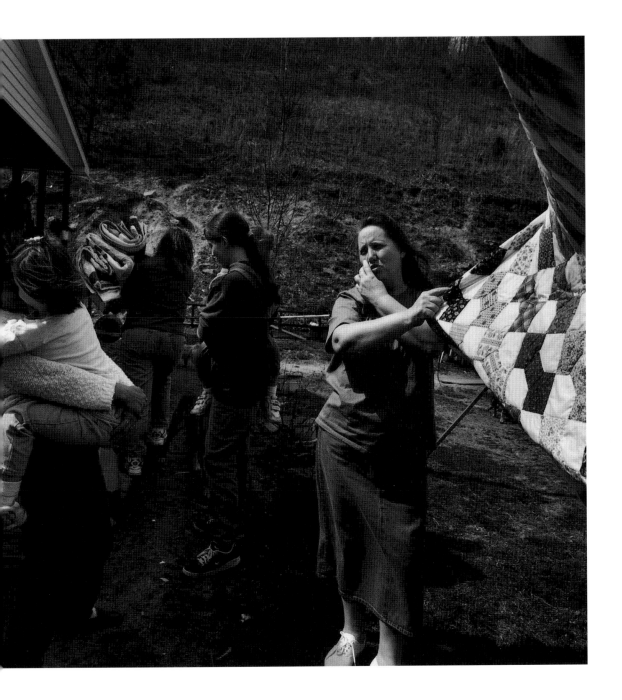

SHOWING OFF ONE OF IREE'S FINISHED QUILTS.
ALTHOUGH SHE OCCASIONALLY SELLS A QUILT, MOST
OF HER WORK REMAINS PILED UP IN A BACK ROOM.

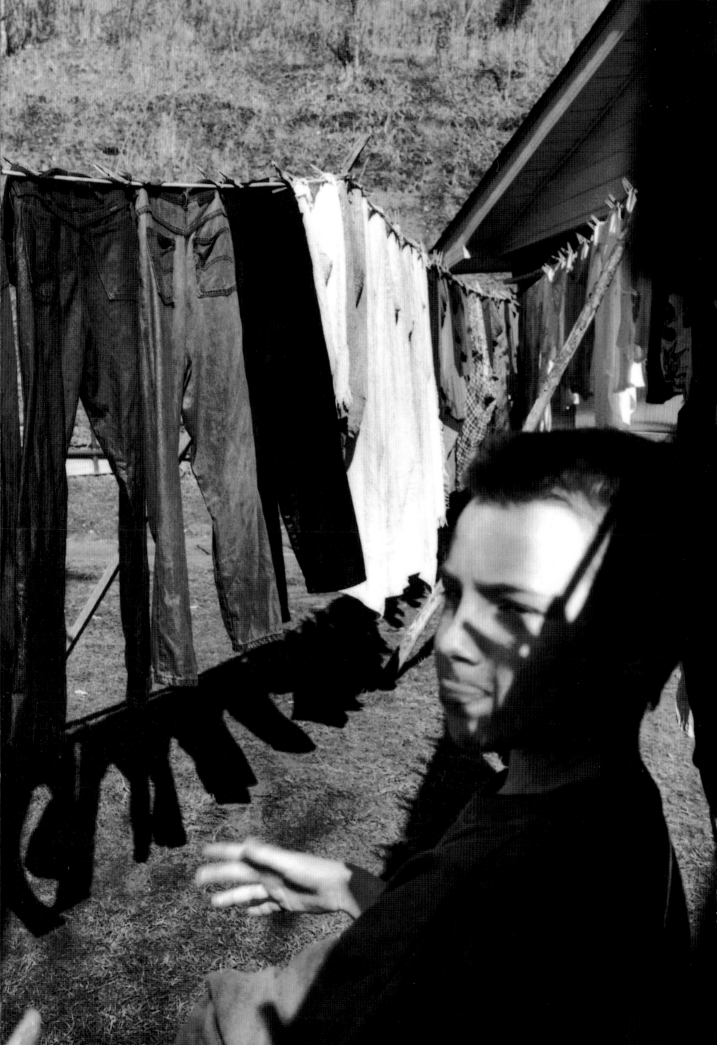

"We get by a lot better than folks in the city. Plenty of room to run, plenty of fresh air, pretty trees to look at, a good garden to work in. Me, the city ain't got no place for."

to sew a block together, so that she could make sure we all learned it. Why, when I was a little girl, I'd get every little scrap she'd throw down or put in the garbage. I'd get it together and sew little doll quilts and things.

I didn't really start making quilts until me and Bass got married. The Ohio Rose was my first real quilt—took me five years. I'd hunt up the material around the house, using old clothes and old things I could make scraps out of, like dresses and pants and the good parts of clothes that nobody wore. And I've done that all down through the years.

I love quilting. I love my quilts, too. Mommy made quilts as long as she was able to sew. And I'll do the same. And my daughter Ruthie, she quilts. She makes quilts whenever she ain't working. So I just try to keep it up. I gave all of my children a new quilt for their birthdays, all thirteen of them.

There's nobody around here in this community that makes quilts now but me. There used to be some, but there's not anymore. Aunt Milda died. She made quilts, but she died with cancer. And Aunt Eva made quilts but she died with cancer, too. Really though, Aunt Milda just made comfort quilts. She didn't never try to make no pattern.

My mother and Grandmother mostly made
their quilts to use. They had to use them for their own
family. They didn't really sell many. Mommy maybe
sold some of hers for twenty dollars a top, maybe thirty-
five for a full quilt. I told her, "Mommy you're giving
them away." She'd do that just to get money 'cause she
didn't draw nothing. Daddy didn't draw nothing either.
So she'd do that just to buy stuff they had to have: salt
and soda and lard, cooking stuff and flour.

But me, I ain't sold any in a long time, not in the
last seven or eight years, anyways. I don't care much
now whether I sell any or not. A woman bought a
bunch about fifteen years ago—took them to different
states. And I imagine folks bought them to use or to
hang on the wall or something. Some were hanging in
gift shops in Phoenix and stuff like that.

I used to go to quilt shows, but not anymore—
'cause of Mommy, I can't leave. I just dropped out,
quit going. Sure I'd like to pay to finish our house, but
I think I'll keep the rest of the quilts for myself, for
when I get too old to sew. I just keep them folded up
for now. I've got a big pile—don't even know how many
really. I'd have to count them up and see. Poor Mommy,
by the time she was too old to sew, she didn't have a
good quilt left to put over her one bed. Her quilt was
all ragged and old, ruffled up. I just folded it away.

LISA RAISOR, AGE
TWELVE, JUMPING.

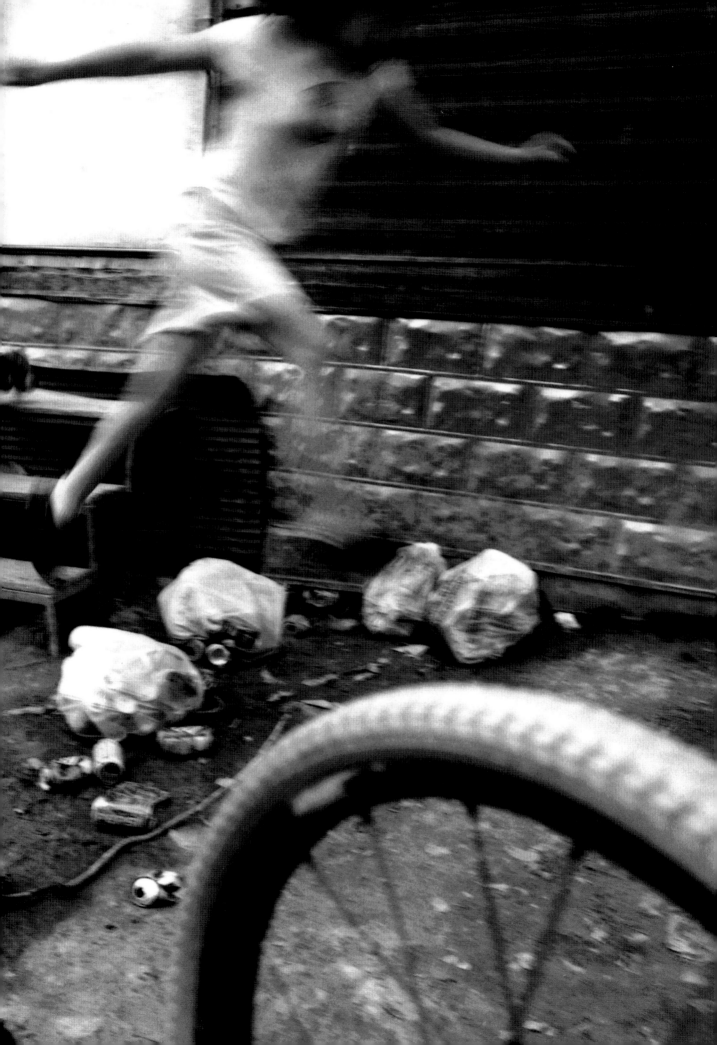

GENERATIONS OF THE FAMILY

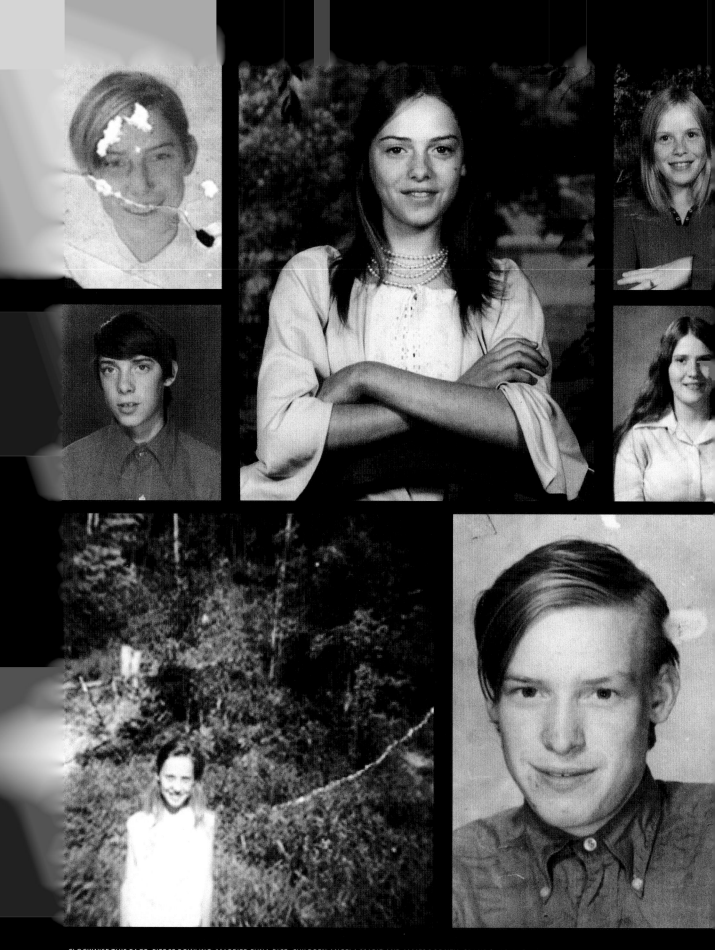

CLOCKWISE THIS PAGE: PIERCE BOWLING, MARRIED EUNA RICE, CHILDREN ANGELA MARIE AND JAMES RODNEY, GRANDCHILD AUTUMN. RUTHIE BOWLING YOUNTS, MAR-
RIED CHESTER YOUNTS, CHILDREN ANTHONY, BRENT, AND NATHAN. BECKY BOWLING RICE, MARRIED RICHARD RICE, CHILDREN SHARON, RICHARD PIERCE, AND SAMUEL.
THELMA BOWLING ADAMS, DIVORCED ROGER HOLLAND, CHILDREN TANYA, JOHNNY, TERRY, AND JULIE, GRANDCHILDREN NATASHA, KEISHA, JOE, AND AMBER. LONZO
BOWLING, MARRIED POLLY DEAN, CHILDREN CLINTUS AND JOSH. IVALENE BOWLING ESTEP; MARRIED BOB ESTEP CHILDREN SAMANTHA AND TINA; GRANDCHILDREN
DEBORAH LEANN, KENDRA, AND DEANA. DENNIE BOWLING, MARRIED BETTY RICH, CHILD MITCHELL. CLOCKWISE OPPOSITE PAGE: DAVID BOWLING, MARRIED IRENE DEAN

CHILDREN KRISTIN AND DAVID MATTHEW. NEIAL BOWLING, MARRIED WANDA JOHNSON, CHILD JEREMY. STEVIE BOWLING, MARRIED PENNY MILES, CHILDREN STEPHANIE, ERIK, AND KEITH, GRANDCHILDREN CALEB AND STEVIE JAMES. BARBARA BOWLING SPERLOCK, MARRIED ROY SPERLOCK, CHILDREN ROY LYNDON, CAROLINE, JAMIE, JAYLEE, SHANNON, AND ROBERT LEE PRESTO, GRANDCHILDREN AMANDA, JESSICA, AND ZACHARY. EDGAR BOWLING, MARRIED RITA DANIELS, CHILDREN BRITTANY AND BRIANA. PATRICK BOWLING, UNMARRIED, LIVES WITH EDITH MOTLEY AND HER CHILDREN, BRANDY MOTLEY, LISA RAISOR, AND ASHLEY RAISOR.

ivalene estep

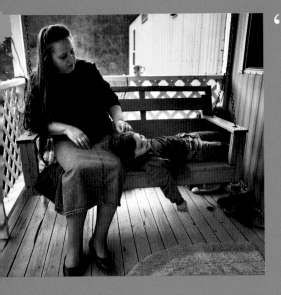

"I've been taking care of kids all my life. . . . It's like this circle we all get in and we're afraid to get out."

I wouldn't, I couldn't hardly imagine myself without taking care of children. My two daughters are grown now, Christina is twenty-four and Samantha's twenty-six years old. And really I've been taking care of kids all my life. All my life.

 Still I wonder how Mommy looked after thirteen. I tell her all the time that I don't see how she done it. Me, I'm the third one down. And I think maybe the last of Mommy's kids, from maybe Neial on, sort of consider me a second mother, really. 'Cause I would take care of them at home while Mom and Dad would walk miles and miles to work. They'd go work in gardens or Mommy would go wash for someone or just help people work in the fields. Big fields, mostly corn, corn and soybeans, stuff like that. And you didn't have tractors back then, they'd done it with horses. So I'd be left with the kids. And I was like a second mother to them.

IVALENE ESTEP, IREE AND
BASS'S THIRD CHILD, WITH
HER GRANDDAUGHTER,
KENDRA. AGE FOUR.

I think this is a nice place to grow up. It was hard but then it wasn't hard 'cause that's the only life we knew. We didn't know any other, didn't know what was hard and what wasn't. But as we got older, we found out we didn't have such a good life. Still there was nice things. There wasn't hardly any crime. You could go to sleep and open your doors and leave 'em open, windows open, whatever. Sleep outside. My brothers, they went out in the hills, they hunted ground squirrels. They'd stay out all day hunting, digging after a ground-hog, and just come home by supper. All the kids knew that we had to be back in the house by dark.

I stayed with Granny a lot when I was young. Just me. I think my grandparents wanted to have a doll around to play with. Granny lived just a little bit out and her and Granddad would come and get me. I would stay with them maybe weeks, maybe a month at a time. Geez, Granny was nice, sweet, just went around humming and singing all the time to me. She was a lot like Mommy, spent all her life in the kitchen and in the garden. That was about her life. And it was pretty much the same for Mommy. Working in the garden, in the kitchen—I guess, that's coming down my road, too. I wonder, it's like this circle we all get in and we're afraid to get out of it.

When my girls, Samantha and Christina, were growing up, I spent all my time with them. I never worked. We did mostly mother things. They'd be around whenever I was just sewing. They'd pick up a piece of mater-ial or something and go to fooling with it. Or when I was planting in the garden they'd walk out with me and play in the dirt.

I guess it's just the way it is. I guess all you know is about all that you can do. I mean, me, I always liked school, I loved school. But I didn't have too much of a chance to go to school 'cause I was one of the older kids. When we got so old, we had to drop out of school and start taking care of the family. And there came just

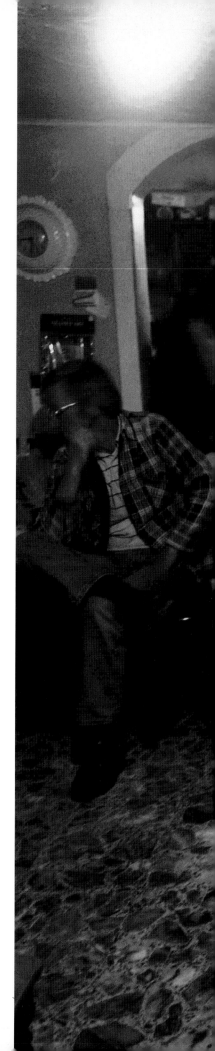

IVALENE (CENTER) WITH FAMILY
AROUND. HER HUSBAND BOB
ESTEP SEATED BACK LEFT.

one kid right after the other. And then when I got
old enough to marry, well you know, your place is at
home then.

But my granddaughters, they love school. I try
to help them with what they do; I love watching them
do it, too. And my daughters are both doing great.
Christina's not living with us; she's married, got her
own home and everything. She's not working right
now, but she was an assistant manager at a Hardy's
before she took time off. Her husband, James, works
in the coal mines. He's a great guy—got a good heart,
a good mind. The coal mine he works at is maybe,
oh, maybe eighty miles away or something. And he
goes there and back every day, sometimes seven nights
a week. It's not too many people around here still work
in the coal mines. Most got old or retired or got into
something else. They'd have to travel far to work, and
it's got so strict. You know, you gotta pass a lot of tests.
Still, I suppose in the long run it's better that they have
to take all the tests they give 'em—too many accidents.

My other daughter, Samantha, is at Mid-South
Electronics. They make ice-makers and telephones.
She drives there every day with my sister-in-law Wanda.
Samantha has come a long way since she left her hus-
band, Jody. She can hold her head up, she can smile
and talk to people. She's a lot better off. And Saman-
tha does a good job with her kids, she really does. Her
weekends belong to them. She takes them out to the
park or a restaurant or something like that, spends
her time with them. But it has been hard for her to be
away working. They tell her, "Mom, we want you with
us," and then Samantha and I, we both tell 'em, "If
Mom don't work, you don't get this stuff she's buying
you." That's how it is now.

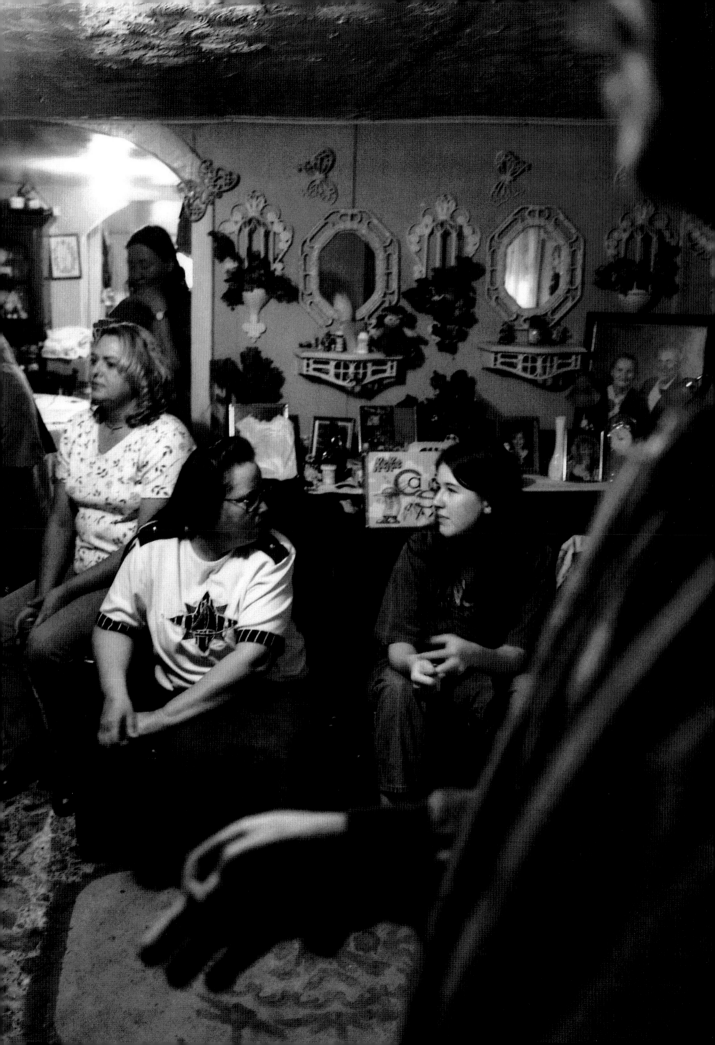

samantha canada

I've been married for six years to Jody—Joe Edward
Canada. We've always called him Jody. We got married
two months after finding out I was pregnant with our
first baby girl, Deborah. And then, after six months,
I lost her. She would have been seven years old in
May. Deborah LeAnn was her name. We got to bring
her home; we brought her to Iree's. And we kept her
overnight and then the next day we buried her.

 After we lost Deborah, that's really when all of
our trouble started. That's whenever Jody started
calling me names and hitting me. And I don't under-
stand why. He said one time that nobody gave him any
pity for it when we lost her, that everybody asked how
I was doing and I guess they never asked him. But
after that it just went down hill, it went wrong. I don't
know what his problem was. He just . . . well, I guess
really he started drinking too much. That was his
problem. When he drinks he gets violent. But he don't
actually have to be drinking to be violent; he can be
violent anytime. Just when he's drinking he's the worst.

 I know that he shouldn't be that way, but he al-
ways has been that way towards me. Still, Jody's never
been violent toward the children. Deana, my baby, is

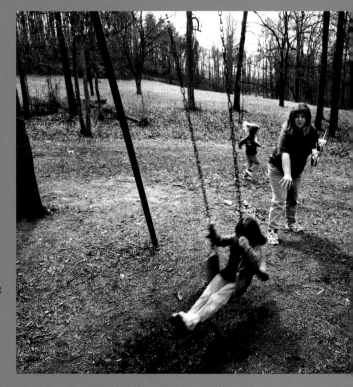

three and Kendra is four. He's always been good to them. But if I even folded his pants wrong, I'd probably get hit for that, for just folding pants wrong. Or if I put too much salt in something, I'd get in trouble for that. I wasn't supposed to have no friends. And I couldn't go outside if he was gone; I had to stay in the house. I couldn't curl my hair or wear makeup. I couldn't wear perfume. I had to wear pants, and couldn't wear shorts and, if I did, he would ask me who I had there while he was out. He was always accusing me of having someone else at the house while he was gone.

Last summer, I went to a safe house in Hazard and stayed for almost three months. Then Jody and me got back together and moved to Georgia. The safe house is a good place to live, but you still got rules and stuff like that there. And you can only stay there for thirty days. They'll help you find a place to live and they'll put you in some programs to find you a job. But you can only stay there for thirty days. If you haven't found a place to live by then, they'll send you to another shelter.

For a while, when I first left Jody, I did miss him. And in all the time we've been together, whenever he

SAMANTHA CANADA, IVALENE AND BOB'S DAUGHTER, PUSHING HER OWN DAUGHTER KENDRA.

was in jail, I'd miss him. I kept going back because I guess I wanted it to work—I loved him. But no more. I've finally learned whenever I'd go back he was real good to me for maybe two, three weeks. One time, he even went for a whole month being real good to me. But then he went right back, always wanting to hit, or to knock, or to kick.

Still, I took it. I said, "Well, maybe he won't do it tomorrow," but tomorrow came and maybe he wouldn't and maybe he would. And it was always having to wait, wondering: Is he going to do it, is he not going to do it? Should I go or should I stay? Because I've had to leave several times during the night. I've had to get Kendra and Deana up out of bed and leave while he was gone. He would hit me once or twice and take off, and I would leave before he got back. If I lived close to a neighbor, I'd go to their house. Or, if we had two cars at the time, I'd take off in the other car and go somewhere he couldn't find me until the next day, when he would've cooled down. And then I'd go right back. I'd figure maybe he wouldn't do it no more. But he always did.

A lot of women at the safe house had been beat on. But my story felt worse. Jody, he wants to beat me 'til where there is nothing left in me to beat on. There's times that I didn't know if I was going to breathe again, 'cause he would have me down choking me, stomping me, and kicking me all at the same time. Nobody up there at the safe house had been done that way. And most of what Jody done to me I have never told nobody. It's too hard to tell, so I mostly keep it to myself. And there is still things that he's done I just even now don't understand.

Like one day, Mommy and Daddy took me to the store and when I come back, Jody had got cleaned up. I walked in with the groceries and saw him and I told him, "Boy, you look good!" And that made him mad. And after Mommy and Daddy left, he started hitting me. I said, "But I just told you that you look good!" And he yelled, "You don't have to tell me that—I already know that."

Now I know that Kendra is getting old enough to remember, and I am afraid that if I stayed with Jody that she is going to see something one day that she isn't supposed to see—like maybe him hitting me or having me down on the floor choking me. Probably, if I didn't have Kendra and Deana I'd take him back. But if you've got kids that's about all you do have. I mean Kendra and Deana is my life. If I didn't have them, there wouldn't be no use for me being around.

here is nothing left in me to beat on."

SAMANTHA AND HER KIDS
AT A FAST-FOOD PICNIC.

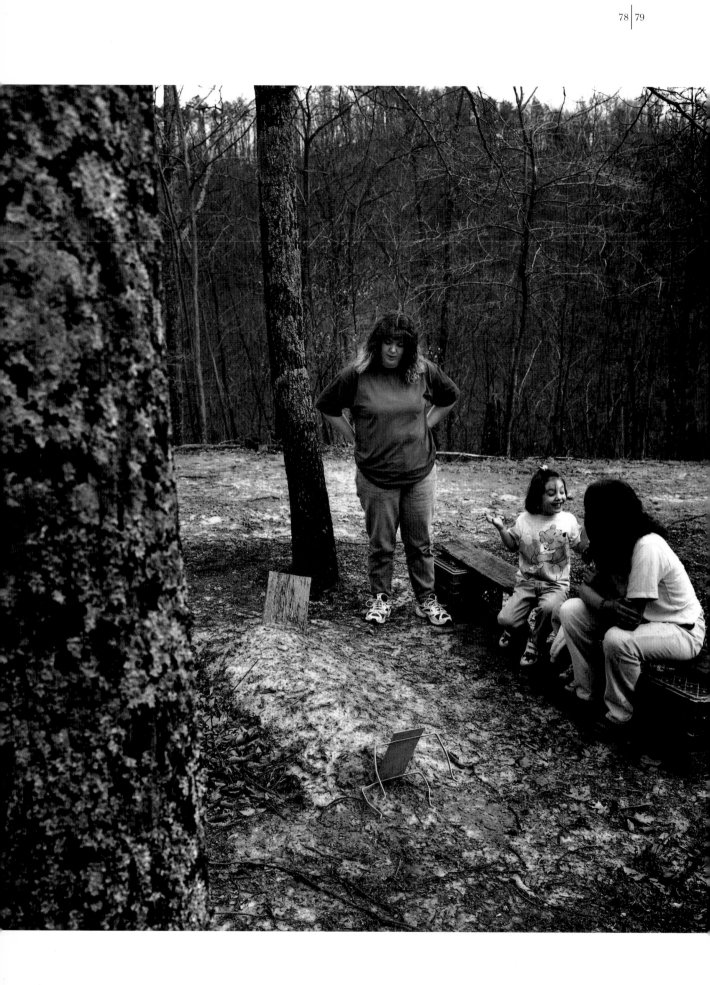

I've been staying with my mom and dad for almost two months. Jody's threatened them a lot, too. Right now, I am afraid for my life. I don't know what he's gonna do next. I can't go nowhere; I can't hardly sleep. At the family reunion, he walked up to me and spit in my face and punched me in my stomach. Then he called me a bitch and took off. I've not seen him since, but he's called to tell me it was an accident, that he didn't mean it. Everything he does is always an accident to him. And that afternoon, after he left, he went to our trailer. He's been staying there since I moved to Mommy's. He went up to our trailer and cut all of our furniture up. He tore the Bible up, took the flowers we had planted and threw them over the hill, busted the TV and VCR, cut the couch and the chair up.

I don't understand. I mean we don't have that much, but whenever he gets mad he destroys whatever we do have. I try not to let it get to me. It's just that he brags about what he does and he gets by with it because he always gotten by with everything. That's why I just can't stand him, 'cause he knows he gets by with everything. And he always leaves me and Kendra and Deana with nothing.

The more I call the police, the more they don't want to help me, because I've had so many calls in against him and they can't never catch him 'cause he always takes off. The police don't hardly want to come over in here 'cause it's so far away, its maybe a little over an hour to come from Hazard. By the time they get here he is already gone. And the social workers, whenever I do call against Jody, they just ask me how come I keep going back. And I tell them I ain't with Jody no more. But the more I call in against Jody, the more it hurts me, 'cause all those social workers tell me is they're going to take Kendra and Deana away.

The only place I could probably be safe at would be the safe house. I probably will have to go back. He don't know where the safe house is and they could probably help me find a place that he wouldn't know about. If I did move out from Mommy and Daddy's and he finds out where I'm at, you just know he's gonna come for us. He says he's got a right to see his girls. I told him that after we go to court we could set up some type of visitation rights where he could see them—until then he couldn't.

He told me today that I had better watch my back, that my time was a-coming. I don't think no one up here can keep him from doing what he wants to do. He just won't give up on nothing. If I go outside I'm scared to death. And if I stay with Mommy and Daddy, I'm scared, too. There's not many choices that anyone can make, at least not me. Just sit and wait to see what happens next.

THE BOWLING FAMILY CEMETERY AT THE TOP OF THE HOLLOW. SAMANTHA STANDS AT THE GRAVE OF HER STILL-BORN DAUGHTER, DEBORAH LEANN.

pat bowling

Rough, let's see. I don't know that I'd call my life
rough. We're making it. I done good. Started out with
nothing, got this trailer. My house is an original house.
It's a trailer but, hell, we live perfect. Got three cats,
five dogs, about thirty rabbits. I pretty well love this
place—couldn't do without it. I always told Mommy
that if something ever happened to her, I was going to
try my best to take care of the land.

Can you find any place more peaceful than this?
If you want to take a walk through the hills, you can
do that without somebody looking you in the face all
the time—without smelling everybody's junk going
down the sewer. You don't have to worry about every-
body else's killing, all that crime going on. You're
right here by yourself, quiet, peaceful. Ten years ago,
well, now back then all of us was more rowdy. We
drunk our beer, we played our cards, whatever.

I still do that, of course—just not as bad. And I
ain't the only brother who still drinks. There's one
more, my oldest brother, Pierce. We still have plenty
occasion to get together and have all kinds of fun.
On a bad day, I drink about eight or ten beers. Then
I say "night-night," sleep 'til about twelve the next
tomorrow, get up, and let the world go on. Start again.

"I'm a Republican wide open and I don't
understand what could make them do this
to us. Democrats are there all the time for
the poor man, always have been."

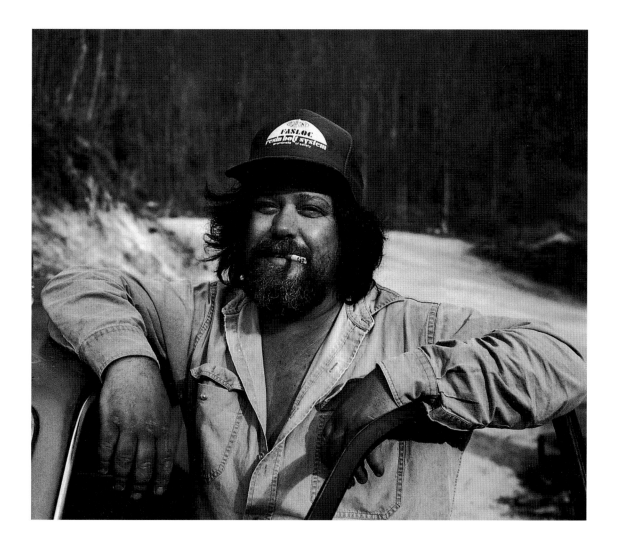

I been arrested one time for drunk driving. I went to jail for drinking four ounces of a Budweiser out of an eight-ounce can. Lost my license for six months. Then I couldn't pay the fines, so it took me two and a half years to get it back.

I've been arrested several times for public drunkenness, six or seven times, I don't know exactly. I just get too happy. It's not that I like fighting like a fool. Drink my beer and let the world roll over, that's the way I like it. But the law never turns up when you need them, just when you don't. You know I bet once that I could call the law and cuss them to hell and high water (which I didn't) and that they wouldn't show up. We're so far back up here they never come. We bet a hundred dollars—I called and told them we was having the awfullest shoot out there ever was. And the law showed; they was here in less than thirty-five minutes, took my ass to jail. Charged me with falsely reporting an incident. Just my luck they was out driving in the area. They put two damn sets of handcuffs on me like I was the worst criminal in the world.

Hell, you can be out on your own road drinking and they'll still pick you up for public drunkenness, and you'll end up spending four hours in jail. They won't keep you more than four hours 'til they send you home. And what they do is they set a court date and you have to go back and pay a fine. I think it is . . . well, it was somewhere around $87.50.

OVERLEAF: PAT, HIS GIRLFRIEND'S
DAUGHTER ASHLEY RAISOR, AGE
TEN, AND FOUR-FOOTED FRIENDS.

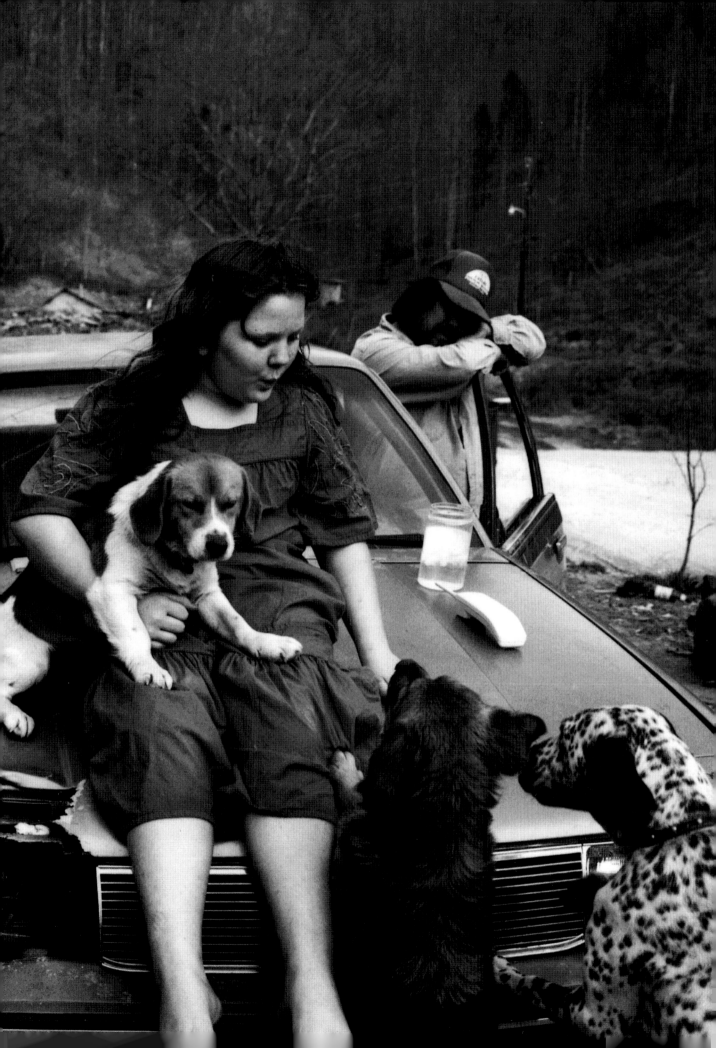

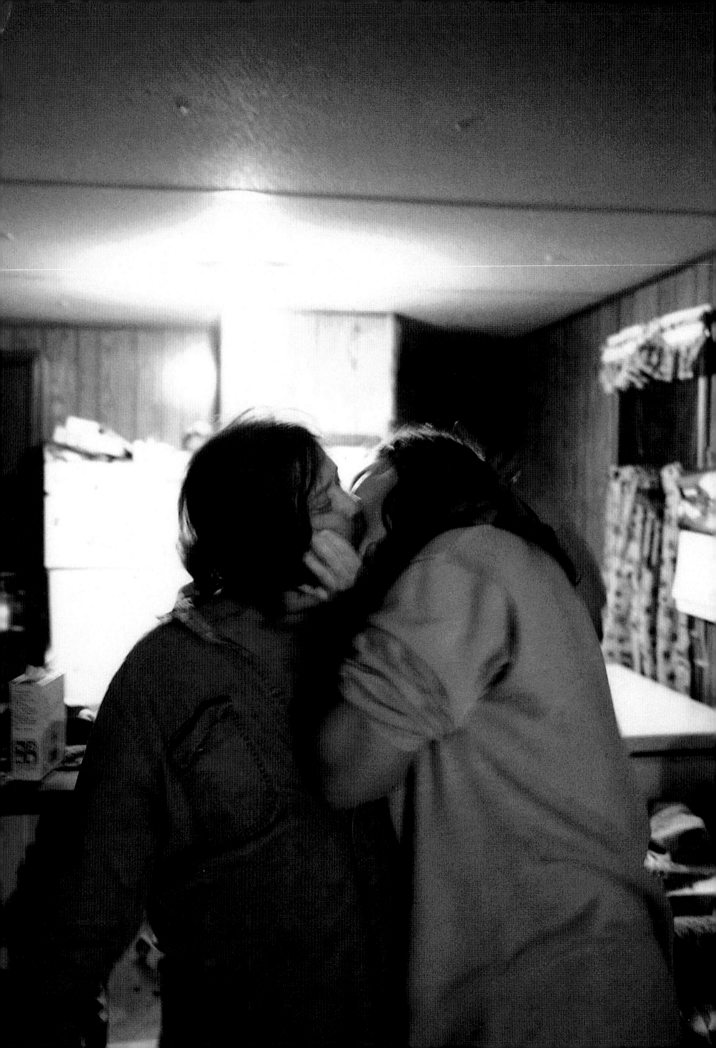

But it's hard to say these days—if you got the money, law won't put you in jail. That's the fact. People they catch with so many thousands of dollars worth of illegal food stamps, bootlegging, or stole motors—they don't spend them even one day in jail. You tell me. There's some who got it, some who ain't, I guess. And as for us, we just live by ourselves and what we can do, we do.

I work on cars. Whenever somebody comes along needs work on their car, I do it. I guess you could call me a shade tree mechanic. I bring the cars to the house, work on them under the shade—that way the sun don't kill me. A lot of mechanics got them in a garage, but I don't. I got them in the yard. I don't got no steady job at it, but they pay me, sometimes. Sometimes with money, sometimes with beer—it depends on who I'm working for. If it's a good friend, maybe I just do it for something to drink. But now I can pretty well fix whatever I want to fix. And I'll tell you something, as long as I been with Edith, been with her and her young'uns, we have never gone without something to eat.

'Course, if it wasn't for the government, we couldn't make it. When they cut out our welfare, it's gonna get really rough around here. 'Cause you really got to have a car here if you want to get a job—you can't just walk to work. If you ain't got no car to drive and you ain't got the money to buy one, and you ain't got no money to buy insurance, how're you gonna work? It would cost me three to four thousand dollars to get a vehicle to go to work. Hell, if I had that kind of money I wouldn't need a job.

That is a stupid bill the government come up with, taking welfare away. You know what the problem is? It's the House. Old Newt Gingrich, I hate that sonovabitch. He shouldn't a never been there. I'm a Republican wide open and I don't understand what could make the Republicans do this to us. Democrats are there all the time for the poor man, always have been. I'm thinking about changing over. I mean if they can go and give Russia billions of dollars, what's my little bit, my two hundred dollars a month, to them? That's stupid. But they'd rather take care of them other countries instead of fooling with their own problems.

Well, I ain't moving for nobody. I've been here thirty-seven years, been gone only seven months. And I don't care if they cut all the government assistance out. They can take everything we got away from us, but they can't take love. And these mountains are too full of groundhogs for me to starve to death. Look at me—I drink my beer, got plenty of food, got rabbits to eat, got dogs to hunt with. I mean what more could you ask for—I love this life.

PAT AND HIS GIRLFRIEND,
EDITH MOTLEY, KISSING.

edith motley

"If there was ever a family to get in close with, this is it."

I went in to get re-signed up for my welfare and stuff. And they was wanting to put me to work. But we're so far away from every place, nothing never did really come of that. They ended up telling me later that if I got something to do around here, I could still keep my check. So Iree wrote up a statement saying she was paying me so much a month to help her take care of her mother—which I was doing for nothing anyway. And I'd been doing it for nothing for nine years. But now since Granny's gotten to where she has to have that place on her tailbone changed and Iree got sick and was in the hospital for a while. Well, Iree started paying me thirty-three dollars a month.

Iree was in the hospital in September. She was on the verge of having a stroke. The doctors told her not to work, but she's set in her ways. She gets out and does it anyways. Like the garden. Iree's on a certain type of medicine where she ain't supposed to be out in the sun 'cause it could kill her if she gets real hot. But she gets out there anyway.

So I keep an eye out on Granny's place when there ain't nobody staying there through the wintertime. I can look right out my door and see pretty much every-thing. And I cut the grass and the weeds out there. It's about knee high right now 'cause we had so much rain I ain't been able to cut it. But I do it every year.

If Iree needs to go anywhere, I'll stay with Granny. And I go down and feed Granny dinner every evening. There some evenings that I change the bandage on her back where she's got that place. She's got a place on her back they call it a bedsore, where she's laid. She's been bed bound for six or seven years. I change her gowns and sometimes help Iree with the washing. About whatever Iree wants me to do, I'll do it. Just to help out. People like Iree and Bass . . . they're a good family.

EDITH MOTLEY, PAT'S GIRLFRIEND,
ON A SHOPPING TRIP TO MANCHESTER.

If there was ever a family to get in close with, this is it.

You know I talked to Iree on the phone before I ever met her. Pat asked me to come live with him, but she was the one who actually talked me into coming down here. And it wasn't so much what she said, it was her tone of voice. She was real light-hearted, just easy to talk to. And Iree's always been here to help me whenever I needed help. I'd be lost without her.

In my opinion, whenever Granny is gone, they'll put her house up for sale. But the boys and the girls will always take care of Iree's place. Neial and Lonzo live on Iree's land now anyway, so there will always be somebody on that property. And, Pat, he'll always be around here. Pat even made Iree a promise that he wouldn't never be away from her for Christmas again. You can't get him away from here now. So even if they decide to move off Iree's place, Pat will still be here—and then so will I.

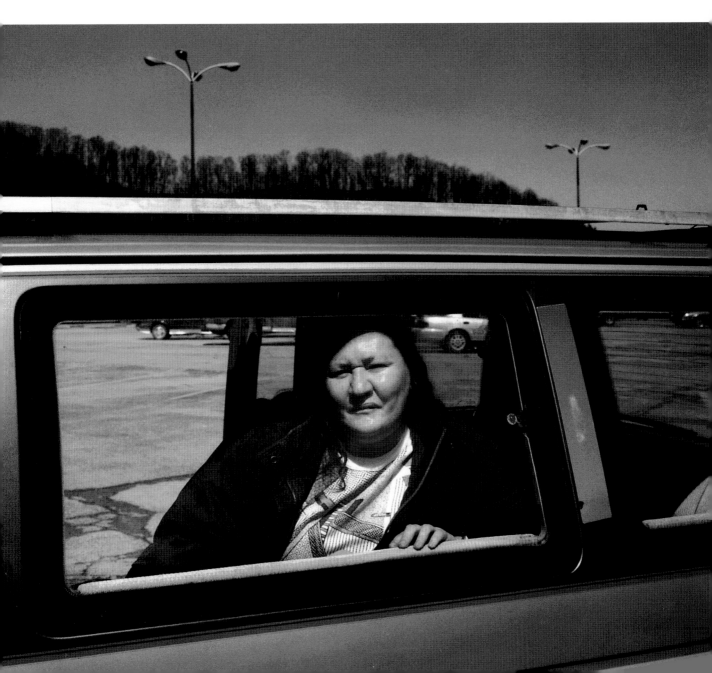

EDITH'S DAUGHTER, BRANDY
MOTLEY, AGE FIFTEEN.

ruthie younts

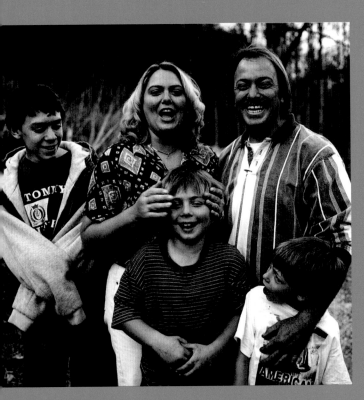

I live in Manchester, Kentucky, about forty-five minutes or so away from Mommy. I'm a teacher's assistant and a bus driver for Head Start—been doing it for almost three years now. Head Start is a preschool program for children the ages of three, four, and five years old. We kinda prepare them for kindergarten. It gives them a head start on things, knowing they have to follow rules and behave when they get in kindergarten and the higher grades. It may take a week or two, but after a while they're not so scared of school.

'Course they didn't have no such thing as Head Start where I was raised. When I was younger, I used to be shy, very shy. I don't know, I guess I was afraid I would say the wrong thing or not say it right. Because maybe I wasn't taught proper language or something, so we were all very shy.

I guess I learned little by little that if I don't take up for myself and say what I feel and what I think, nobody's gonna do it for me. And I just figured, I might as well liven up and quit sitting around so quiet. Now they tell me they can't get me to shut up.

I was the only one out of all of Mommy's kids, out of all thirteen of us, that graduated from high school.

THE YOUNTS: RUTHIE YOUNTS, IREE
AND BASS'S TWELFTH CHILD, HER
HUSBAND CHESTER, AND THEIR THREE
BOYS, CHESTER JR., BRENT, AND NATHAN.

"If I don't take up for myself and say what I feel and what I think, nobody's gonna do it for me."

I was the only child. I think it was because I just loved going to school and I enjoyed having friends. It was something to do besides sitting in the house, doing nothing but cleaning and cooking and helping around. And all my brothers, they was thrilled for me. I'm number twelve out of my brothers and sisters. I'm the dozen. And the whole family was tickled that I was graduated. They were glad they could say, "Well, if I didn't, at least she did."

When I got married, my husband, Chester, he logged for this man who lived in Clay County. Chester did not want to live in Leatherwood because he wanted to be able to get back and forth to work and be able to take care of me, too. So we moved and it was pretty hard for a while, having to leave Mommy. You know, Mommy was my world. When I left, it was like, "This is it. I'm not going to make it." I was only twenty when I left and I wasn't prepared. I didn't know what I was getting into.

But you live and learn. You learn things that you wasn't taught, but that you want to teach your children. You get what I mean? It's just like they say, a parent is a child's primary educator. We're the ones that really teach them what they need to know in life. My mother, Mommy, always made time for all of us. One way or another, you know. She may have not been able to do it right then and there, but sooner or later, she got around and she made time for each and every one of us.

Me, like when I was little, I went to church regularly with Mommy. Daddy, too, he was the driver. And when I got up in high school, there was many a nights not getting home sometimes 'til about twelve after I'd been with my mom to church. Church was sometimes an hour and a half away. It was just according on where Mommy wanted to go. And she went a lot, a lot a lot. There's seven days out of the week and I'd say Mommy

PULLING
NATHAN'S TOOTH.

probably went five. And I'd have to get up at, like, five in the morning to catch the school bus at the end of the holler. It was pretty hard, but I did it.

We all knew that Mommy loved us, and we all knew that Daddy loved us. Daddy just showed it in a different way. But Mommy had her special way of helping us out. And she mostly treated us all the same. You see, that's the part about it—Mommy's main goal for right now, she would love for nothing more in this world than to have all her children go to church. But even I guess, she would love just to have all her children be good to each other, to love each other, and never let nobody break them up. Because I think we're a very fortunate family. See the youngest one, he's thirty-three years old and, well, we are all living. We're fortunate to have all our brothers and sisters alive. And it's just, I don't know, we should be glad and jump for joy, and just spend more time with Mommy and Daddy and say, "Now looky here Mommy, we're staying here. There's nothing you don't have to worry about—we've not left you."

I know that Mom has it hard sometimes with Dad being a diabetic, and she has her high blood and her heart condition. Now they say she's a diabetic, too. It gets pretty bad when you have a home with two diabetics. And she takes care of her mom and sister. But I'm telling you, she's a strong powerful woman.

You know, Chester and I still go over to see my family about every Sunday. And I look forward to my Sunday, I don't make plans for anything else. During the week I get pretty tired out, what with driving a bus and taking care of kids at school. And my own kids, that's all they holler, "Let's go to Grandma's." They like being able to just get out and go and run. They like to climb hills. No, nobody interferes with Sundays. That's our day. And I just love to go to Mommy's.

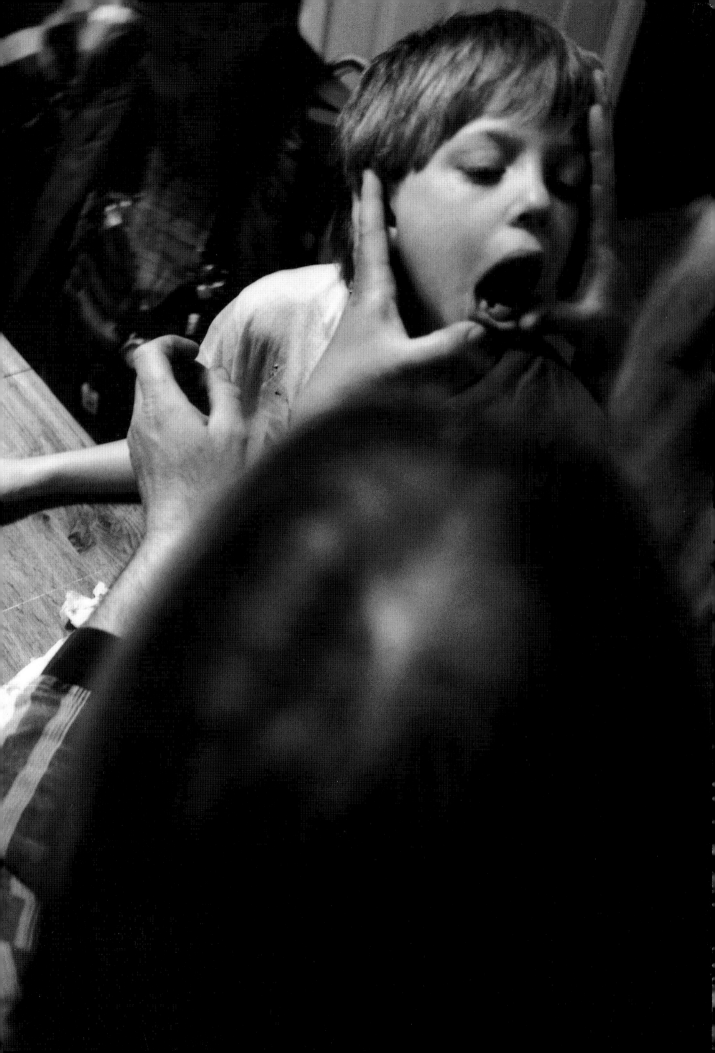

lonzo bowling

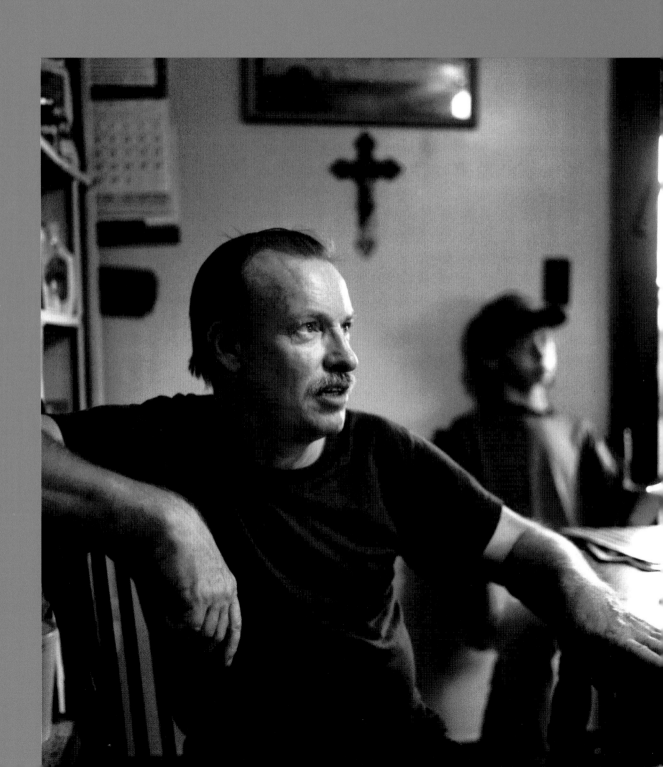

"It's been a rough road—I mean a rough road all the way through."

Now accidents happen—but they usually seem to happen when you're drunk. Every bad accident I've been in has been on account of drinking. You see, I used to drink a lot. I figured I'd take up the family tradition. And it's been a rough road—I mean a rough road all the way through.

I went to jail and did my time, for drunken driving, disorderly conduct, starting fights, you name it. Drinking messed me up pretty good. My head's been through a car dash more than a couple of times. The first wreck, I was just a child. It was my brother's fault. He was drinking and I was just riding in the car. We was right there at the top of the hill, coming home at fifty miles an hour, and we hit that cliff sideways, head-on. They thought I was dead; they was getting ready to bury me.

In my last wreck I went through a windshield—that was about five years ago. We was drinking early that day and I guess I must have passed out. We went over a hundred-foot drop, that's what you call flying. We was like the *Dukes of Hazard*. I woke up in the hospital thinking I'd been put in jail, and spent the first three weeks trying to break out. My head was my trouble. I forgot how to read, how to write, how to count. They learnt me how to walk again, learnt me how to talk—I was pretty tore up. You know how much they charged a day for me to get back on my feet? A thousand dollars a day. And when I got my medical bill it was over a hundred thousand dollars. But you know, the government picked it up.

If you look around, this is a dry county now, but I sure remember when it was wet. 'Course, folks can still get liquor just as good—have to pay double is all. Me, I'm just glad to get my Prozac. You'd be glad, too. Four years, ever since I got out of the hospital, I been taking it every day and every night to keep going. I take it for depression and stuff—when I get near that sleepy edge.

You see I'm used to working, having a job, and making my own way. I lived in Cincinnati, and in St. Louis, and in Florida for about twenty-six years. I worked every year for twenty-six years. Used to be a steel burner, now look where I am, sitting like a damn dog. My doctor won't let me go back to work. Not ever. They say I'm getting worse. I went to the hospital last month, they put me in one of them machines and said that my brain was going, said that my brain cells were leaving.

We live rough alright, and we are having a hell of a life, but I live it one day at a time. I don't drive anywhere or do nothing anymore, but I suppose I've come a long way. They say one more hit of my head could finish it forever, one small hit could kill me. Sometimes I feel depressed. But you know, I know I'll make it through. I know I'll make it.

LONZO BOWLING, FORTY,
IREE AND BASS'S FIFTH CHILD.

LONZO'S WIFE, POLLY
BOWLING, WITH THEIR OLDEST
SON CLINT, AGE TWENTY-ONE.

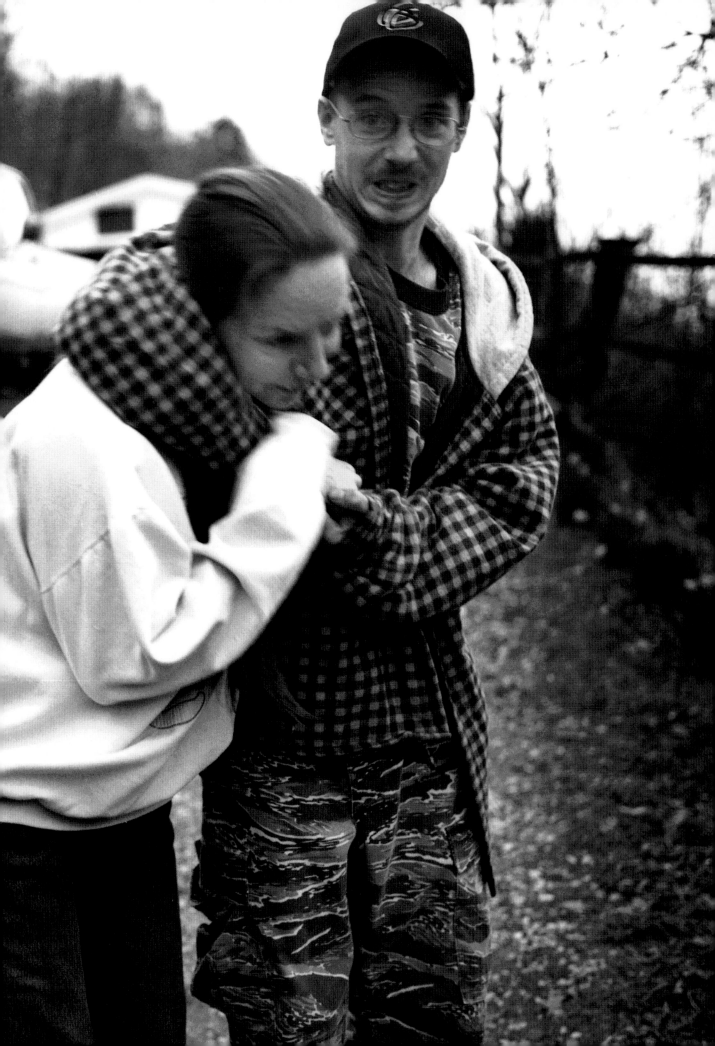

polly bowling

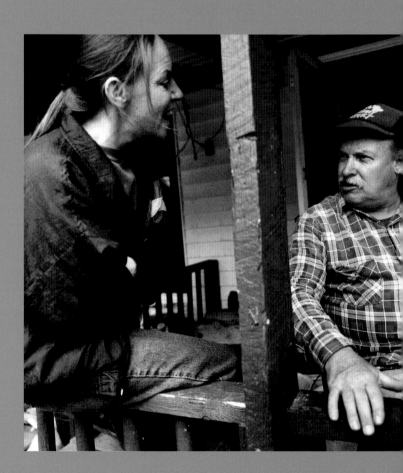

"I'm not saying that there are not jobs, but they're about thirty maybe forty, miles off."

I met Lonzo in Cincinnati. He was running around with my brother and one of my sisters, Mary; they were friends. He told my sister he would like to meet me. He went by the CB handle of Cincinnati Kid. He called me and asked me if he could take me out, to meet him on the corner 'cause he was afraid of my mom.

We dated for a long time and then we started living together. We lived together for fourteen years before we married. After we was living together two years we had our son Clint. All and all we've been together for twenty-two years.

We had moved down here several times, back and forth several times, me and Lonzo. See I couldn't make up my mind if I wanted to stay up in Cincinnati close to my mom or stay down here. But I was really glad when my sisters Wanda and Betty moved down here. And then my sister Mary she moved down here, I forget what year it was. We're all pretty close. My brother, even he just moved down here after my mom passed away.

Lonzo and me, we was married in '91, and that's the time we moved down here to stay. It was hard for Clint to move 'cause he had a lot of friends up in Cincinnati and it was strange, but he got used to it. He was in, I think, the sixth grade. But he made friends right off and now it doesn't bother him. Kentucky, I mean here, is a better place for Clint. If we would have stayed in Cincinnati, he probably would have been in a heap of trouble by now. He was running around with the wrong crowd up there. But still, it's also hard for him here—Clint doesn't have a job. There just aren't many opportunities here. And I mean, with my situation. See, I have a sick husband.

I have to be where Lonzo can be watched. His doctors up in Lexington don't want him to be doing nothing that he's not supposed to be doing. If Lonzo gets in the hills by himself and was to trip and fall and get hurt, he would probably get paranoid and wouldn't know what to do for himself. And it would be hard for us to find out where he was at. He can go and do these things, but not by himself; his brother Neial or Clint, or somebody has to be with him.

When my mom was sick and we was taking turns about going to Ohio, everybody was thinking Lonzo was probably by himself, but no he wasn't. Both my sons were here or Wanda or Betty or somebody would always come and check on him, to make sure he had his medicine, something to eat—that he was getting along alright.

And with Clint, now it is difficult because he is still not working. See he don't have a car. We're having trouble getting his driver's license 'cause we have to wait six months. And you have to have a driver's license and a car to get to and from work. And it's really hard for him. You know, he wants things. He wants money, he wants a car, he wants to travel and he can't do that now.

I'm not saying that there are not jobs, but they're about thirty maybe forty miles off. And maybe I could go out of my way and take Clint to and from work if he got a job, but you see it would be hard on me. I would have to get up, get Josh off to school (hopefully in time), then I'd have to get Lonzo up, take him with me. It would be just a big problem for me.

At the time Clint and Shirley were going together, Shirley lived in Hazard. I had to go pick her up from Bob Fork. See, her mother would bring her to Bob Fork, maybe twenty-five minutes away. I would take Clint to meet her there every weekend, sometimes every other weekend. Lonzo would have to come with me. It aggravated me that I had to do it 'cause I hated the idea of him marrying Shirley. But I done it for Clint.

Shirley was the type of girl that wanted Clint to do everything for her. Clint was not allowed to go play ball with his friends, he wasn't allowed to spend time with the family on Christmas or Thanksgiving 'cause she would get mad and they would get into a big argument. So when they were going together, he was always in the house. It really made me mad.

I had met her mother a couple of times, but you know we really didn't associate with one another. Her mother, well, we was just from totally different people. To me her mother and her people, you know they had money and they had things that we didn't have. And while Clint didn't let on like that made it hard for him— probably it did. But no, I didn't like the idea and I'm glad, very glad that he didn't marry her. He was just too young.

I mean I know I started out young. I really did, and I'm sorry that I did. I mean not right now, but back then when I was away from my mom, then yeah I wish I would have listened. But Clint just felt like everybody was against him. I tried to explain to him, "No Clint, they're really not against you. They're just trying to give

you good advice and tell you that it would be better for you to wait." But you know teenagers, they don't see it like that.

Now that he thinks about it, he's glad that he didn't marry Shirley, too. But since her, Clint hasn't met anybody else—not yet he hasn't. Down here it's a little community. Either you might meet a girl at school or a friend's friend's sister or something like that. That would be the way they would do it here. It's not so hard. Clint's told me he talks to a few girls, but since Shirley he's not really gotten serious with anyone. And I'm glad that he's not.

SHARING A HUG. POLLY WITH HER SON CLINT AND HER SISTER WANDA (LEFT).

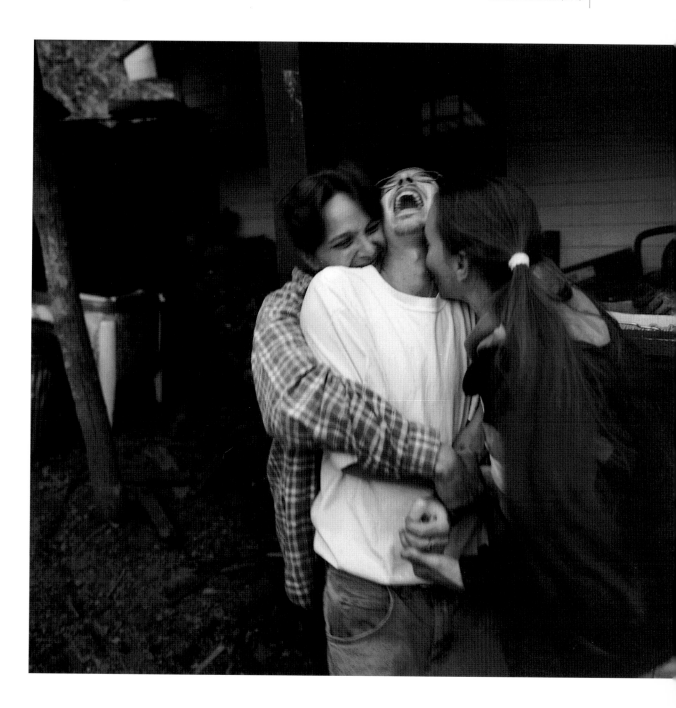

clint bowling

See where I am, how we got to live? I'll never get no
chance to be nothing. Sure, maybe I'll get a job some-
where, but I'll still be a nobody, doing nothing except
breaking my back. Just like everybody else around here.

My uncles, they ain't doing nothing now except
living month to month getting a check and digging
roots. That's a great living ain't it? And every one of
them, except a couple, are doing the same damn
thing—nothing. And they'll never do nothing except
stay on this damn creek. My daddy, he worked a lot.
Now he can't work hardly at all. And we can barely
make it each month.

I hate this place. The rest of this family may like
it here, but I hate it. You can't breathe without some-
one wanting to know what you're doing. You can't
turn around without someone trying to tell you what
to do. Saying: "This is our house, we live here, we pay
the bills here." At least I'm trying to help out around
here, whatever it takes.

Everybody said, "Get your high school diploma,
you'll get a job." Well, I got it. I dropped out of high
school as a senior and then I decided to go back. I
graduated so I could make something of myself. And
you can see I ain't doing nothing now. I've tried. A lot
of my cousins are dropouts; they ain't went back to
school. And not one of my uncles out there has a high
school diploma; some of them didn't ever get through
grade school. And they have the nerve to tell me what
to do with my life.

I'm twenty-one years old, I'm responsible enough
to make my own decisions, what I do is my business
and my choices are mine to make. But, you know,
there's other people in the family that don't see it like

that. The family out here is always judging me and trying to control what I do. I don't think it's right. I've got a different personality than they do. I like to voice my opinion when everybody else shuts their mouth and maybe sometimes they don't agree with what I say.

I was born and raised in Cincinnati most of my life. That's what I was used to, the big city and the way things work up there. And I think that is one of the reasons maybe that I don't hold high in the family's view. But I got to be my own person—and I don't do everything they do. I like my kind of music and my kind of clothes; I like rock-n-roll, I like rap. I like to wear my clothes baggy.

I guess you know, I had a pretty rough time last year. A whole lot of trouble with a whole lot of things. I was having trouble at school, trouble at home, trouble trying to get a job. Most of it was with my fiancée Shirley—well, she was my fiancée back then. Man, I was having a lot of trouble. It was all pretty rough.

Plan number one was to get married, then get a job. Shirley, she lived in Whitesburg at the time and they got jobs up there. More than likely, after we got married I would have moved to Whitesburg, found work up there, whatever I could get. But now—I haven't talked to her in a year. I don't think I could even stand to see her.

I was ready; I was ready at the time. For me she was the one. But I don't think that Shirley was ready to get married. And I'm pretty sure that somebody talked her out of it the night before our wedding. When I left her house the night before, she was ready. I called her the next morning at about 6:30, 7:00, on our wedding day— she was ready then. But when I called back later, it was a different story.

You know, I was always the one trying to keep us together and work things out and this and that. My first real true love and all that good stuff. It was hard for me to let go 'cause she was all I knew then. I didn't think I could live without her.

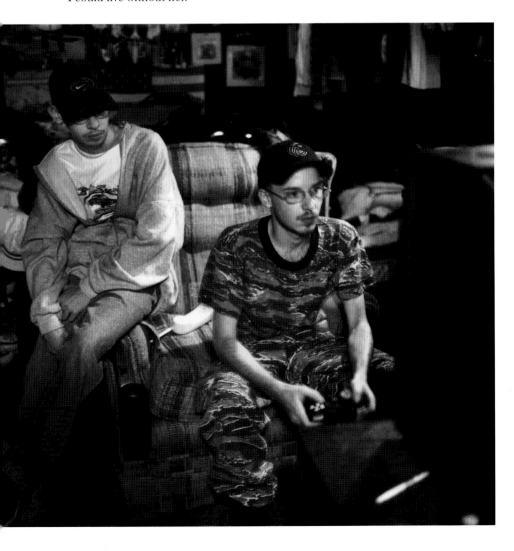

CLINT AND HIS BROTHER, JOSH,
AGE FIFTEEN, PLAY VIDEO GAMES.

My mom didn't like Shirley too well, but then there was times when her mom didn't like me too well either. Although in the end, her mom was for us getting married and all and my mom was against it. But my mom, the way she is, she said, "I don't approve of it, but it is your life Clint,"—and she was behind me no matter what.

My mom and dad, they always try to stick up for me. They usually support my choices and what I try to do 'cause they know I'm a man. I don't know, I was crazy in love with that girl. I was absolutely obsessed with her. She was my everything and it is hard to let that pass. I try to forget it, but it is still there, in the back of my mind. Now I move away and come back, move away and come back. It is hard down here man, it's whatever you can find you got to do.

When I went to Ohio, I had a job I was working making real good money at a BP up there. Every paycheck, I'd send money home to Mom and them. I liked it a whole lot, the work and all that, but the situation I was in was pretty tough. It wasn't that I couldn't support myself. I had plenty enough money to pay the rent, to buy

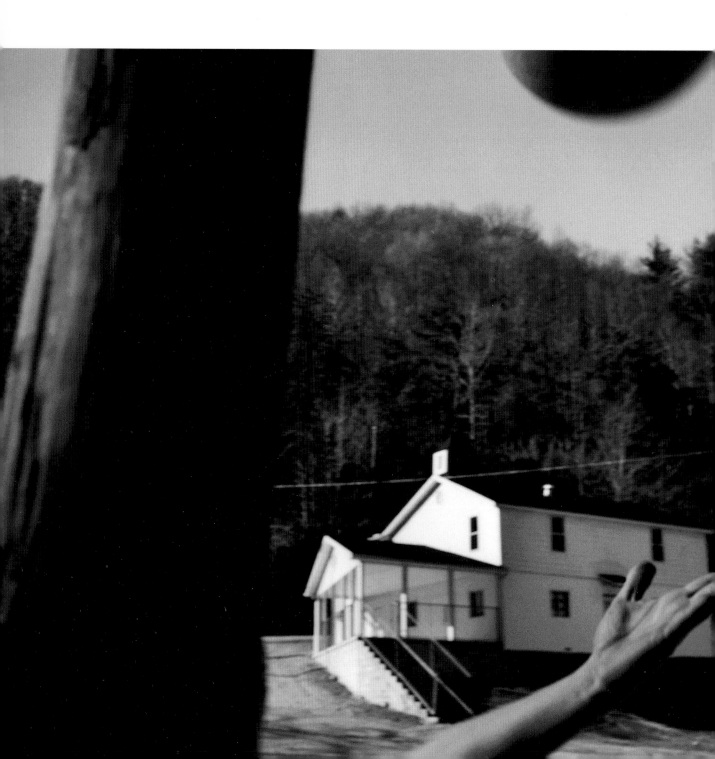

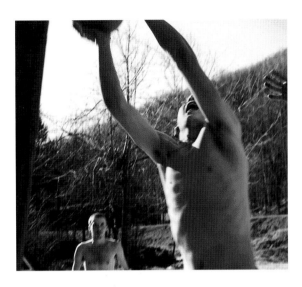

groceries, and this and that. Whatever I needed, I had money for it. I had a cell phone just because I wanted one. But I was staying with my cousin and her boyfriend and her baby and I worked at the same place as her. Her man, her baby's daddy, he was sort of, I don't know how to say it. He was just mistreating her you know and I would end up stuck in the middle 'cause I don't approve of that sort of thing. So me and him was having words. I kept saying, "I ain't going to stay up and live around this guy, because he's no good for you and we're gonna end up in trouble." So first chance I got, I just come back 'cause I didn't have nowhere else really to stay—so I just moved back.

Right now I try not to stay home as much as possible. Just being here is pretty tough. I see how my mom and dad has to struggle just to get us food. I see the worry when it comes time to pay bills. And there's a lot of memories here too. I get depressed a lot; I get mad, so I try to leave as soon as I can. I'll be leaving here shortly again.

There's nothing here. Most people just have to get welfare or dig up in the hills, take a chance on getting shot or bit by snakes. Most of my family goes into the hills to dig roots. And everybody talks about me, saying I ain't doing nothing, that I don't try around here. Ain't none of them says, "We got faith in you, we'll help you out." My uncles think they're so great, but they're doing nothing now—just waiting on a check every-month. And it has always been that way.

I'm a young man, I'm twenty-one. I can have fun if I want to. Just 'cause I don't have fun like they used to way back God knows when. I do what I want to do, but I'm their choice to pick on—sort of like the black sheep. And they claim to be church people. Church people don't judge you.

See, that's the problem with people round here, all they do is talk.

OUTSIDE THE OLD SCHOOLHOUSE
IN SAUL CLINT SHOOTS HOOPS.

neial bowling

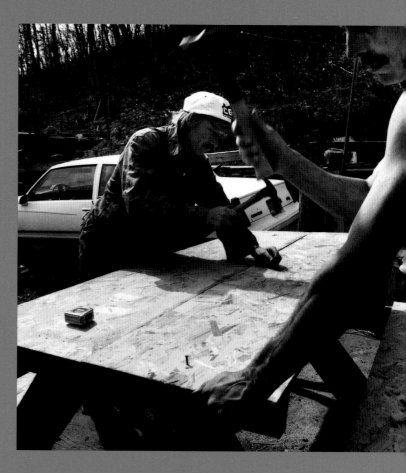

Root, hog, or die. You got to get out there and try to make you some money 'cause you ain't gonna make nary a dime laying on the couch. There's no money floating around here—nobody's got no money. Most fellas just got what they draw from welfare and what they dig out of the hills. Very little. But still, I guess like a lot of things, if you know what you're doing you can make it.

There's guys live right on the creek here, they got their own carpentry bunch and they get a fair amount of work. Just this September of last year I got a job doing carpentry work. We build them FHA homes, Farmer's Home Administration. It's federal housing stuff, low-income housing they call it, but low-income folks can't afford one. I mean people don't hardly get no lower than welfare and food stamps and they can't afford to buy one.

You can always make money digging roots. It's a seasonal thing, though, starting in the spring from March to about the first of October. Through the winter months you can gather some moss. If you're raised up doing it, you know what to look for and what it looks like. See, anybody can pay a TV bill, you can scratch

NEIAL BOWLING, IREE AND BASS'S
NINTH CHILD. A CARPENTER, HE
BUILDS HOUSES FOR THE FARMER'S
HOME ADMINISTRATION (FHA).

that out of the dirt. If you need a new pair of shoes, you go dig you some roots. Me and Wanda needed a kitchen table, I went one day and dug enough roots to buy it, cost forty bucks. It's cash money, but well, the money don't come every week.

About ten years ago, we used to go up to Lexington in the fall and cut tobacco. We just sleep on the ground at night, cut tobacco all the next day. Right out at the river you could pay a dollar to take a shower. That was the first good money I ever made. They paid you six cents a stick to cut tobacco. And I had never made fifty dollars a day in my life.

On weekends, I still like to get out into the woods. I like gathering moss, and I like digging roots. Sometimes, why you may come up on a patch of ginseng, maybe dig more out of one patch than you make in two or three weeks of work. Ginseng, bloodroot, stoneroot, yellowroot, bassroot, grapevines, sassafras leaves, star root—you can just about sell anything. I've never been nowhere in my life where you can live any easier than right here in this part of the country. It's always been easy enough to make it around here, if you weren't too sorry to get out and do something. Now, if you're too sorry to get out of the house, that's another story. Then you ain't gonna have nothing.

'Course there's good times for digging roots and not so good times. Bloodroot ain't worth digging right now. Brings a dollar a pound wet and about six dollars dry. The market's flooded. There are so many other roots that make more money, you might as well walk right on by bloodroot. A pound of dry ginseng, now, that's a different story altogether. A pound of ginseng will bring as much as $240. 'Course, you got to dig a little over four pounds wet to get a pound of dry. But it all depends on how it dries out. You never do know how much a root's gonna dry up.

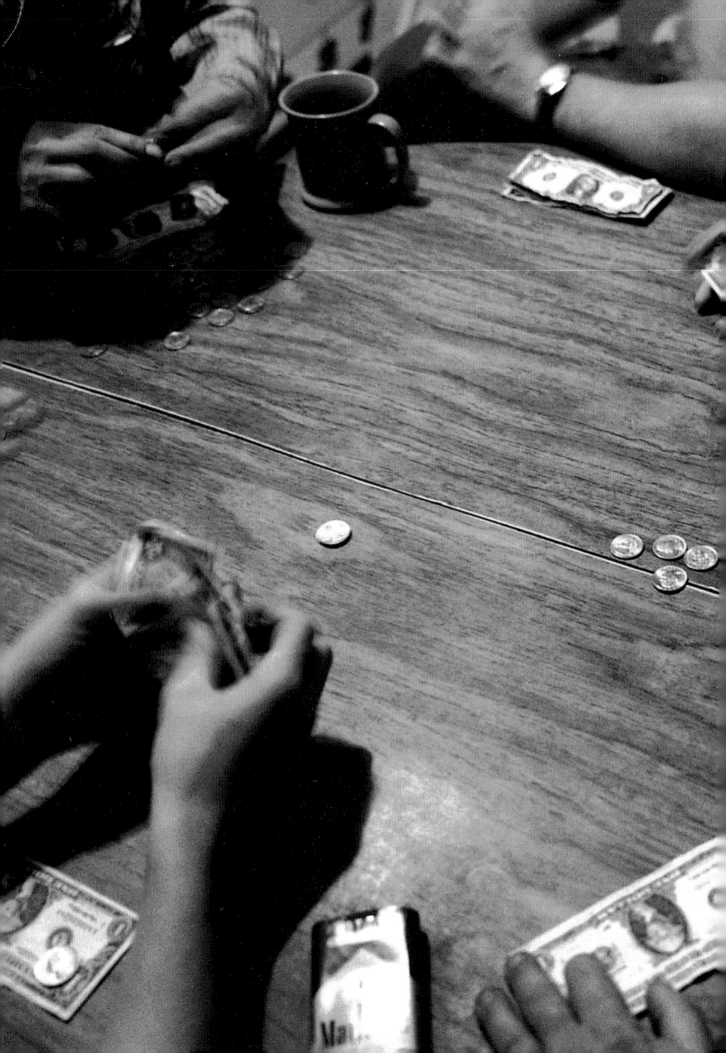

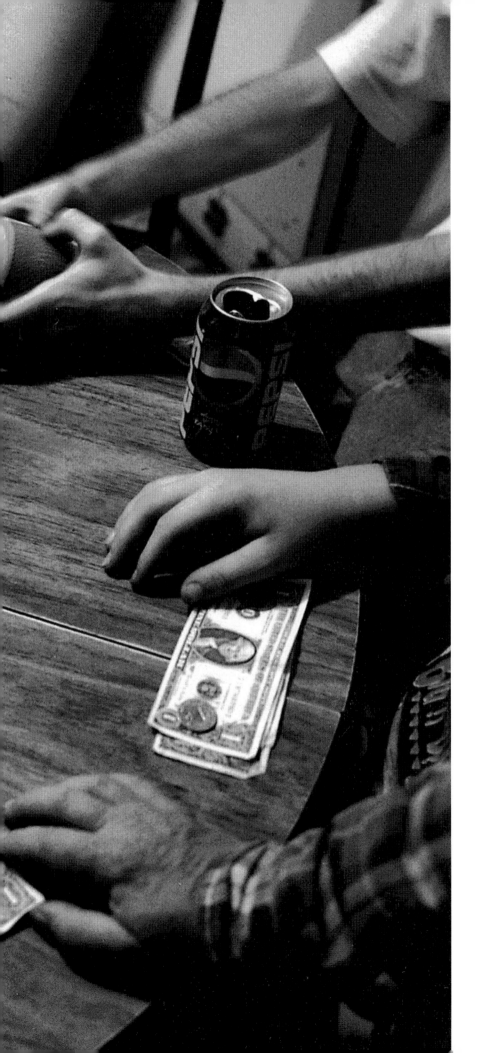

POKER, SATURDAY NIGHT.

NEIAL SPLITS THE WINNINGS
WITH HIS WIFE WANDA.

"Ginseng, bloodroot, stoneroot, yellowroot, bassroot, grapevines, sassafras leaves, star root it's always been easy enough to make it around here, if you weren't too sorry to get out and do something.

I dry my ginseng in a dehydrator, it takes about twenty-four hours. Some of them dry up pretty well, but others, you ain't got nothing left at all. If you don't need the money right away, let it dry in the sun. Just lay it in the back of a windshield of a car in a pan. It might take as much as a week to dry, but it'll look the best.

I sell most of my ginseng to the highest bidder. They use it to make medicine; they do a whole lot with it. A lot of guys will try to cheat you out of what you got; they won't give you an honest weight for it. Still, you got five or six different buyers around here who want it bad enough, so you just take it to the higher bidder.

Now my son, Jeremy, has dug bloodroot and wild yam, but he don't know ginseng, that's kind of hard to learn. Knows how to gather moss, though. 'Course, you gonna have to pick through what he drags off. But moss is moss—seventy cents a pound after you hang it up and dry it out. Its worth getting if you can find enough, but still you make more money digging ginseng.

I try to teach Jeremy what I can. I mean, heck, I'd like for him to have it a lot better than what I had. But you know, most times circumstances just stick you where you are. He may grow up here and like it. He may not want to leave. And the way I see it, times ain't gonna get no better, they're just gonna get worse. And Jeremy needs to learn everything he can, any way to make a dollar, you know. If it's digging roots, or gathering moss, or busting rock.

We'd like to buy a place over in Clay County. They got a little flatter ground over in there. I mean, I'll have to wait until the next ice age comes along to have flat ground around here and that may be a while. I already know where the place is. It's a house and a barn, about two acres of ground for twenty-two thousand. That's a lot of money. By the time you finance that it comes to forty-four thousand, the way they do it around here. Most vehicles cost more than what they want for that farm. There's people pay more than that for a truck.

And you know, I just can't afford to drive around in a small farm, can I?

wanda bowling

"The story goes like this: three sisters ended up marrying three brothers."

The story goes like this: three sisters ended up marring three brothers. Me, my sister Polly, and my sister Betty, we all married Bowling brothers: Neial, Lonzo, and Dennie.

It's kind of odd. But we're all still with the same person, so it was probably always meant to be. And it's fun—I'm glad I got my sisters with me, keeping family together.

How it come about is Lonzo used to live in Cincinnati and work. And Polly met Lonzo first and that's how it all started. I am the baby of the family, the youngest. Lonzo and Polly were together a long time and then when they were coming down here one time, I guess it was a weekend visit, they brought me along with them. That's how I met Neial. And before any time had gone by we got to liking each other. But I didn't stay. I went back home and we wrote letters back and forth for probably about four years before we ever married. It was like a long-distance courtship. And I'd visit every chance I could.

For me it was an all around different way of life down here. But since I've lived here nineteen years, I can't live in the city. I know that sounds weird, but I just can't. You ain't got all the traffic and all the

gang-related violence and all the drive-by shootings. I like to go back up and visit my people, but as far a stay-ing—Nooo. When my sister Mary's husband died, I went and got her and brought her down here. And we didn't have our brother until after our mother died. He come down here to stay with us girls and now he's got a woman, he's living down here. There are four sisters and one brother down here now and we're very close.

Our mother couldn't figure out why we liked it down here. She was a city person. But I'm definitely not. This sort of life is just second nature to me—I've always liked the outdoors. To me, in Cincinnati, it was just plain hard, and city life was never less than rough living. I was poor then. And I'm poor now. But here it don't bother me to live like this. If you live in the city and you don't got money, you're hurting because rent and just about everything else you need is expensive. You can live here easier, the bills ain't that much. In Cincin-nati, before I had my little boy, Jeremy, we paid 150 dollars in rent and probably the same amount in electric.

Have you ever watched *Hollywood One-on-One*? It's where they talk to the stars about their lifestyles. Well, that's not me. Me and Neial, we don't have much. And I still got to watch how I spend my money 'cause it's tight. I don't have an inside bathroom, just a . . . well, you'd call it an outhouse. It's 1998 and we just last year put running water in the house, into my kitchen sink. We did it ourselves. We bought line, hooked into Iree's well, dug up a ditch, and ran it to the house. But I still need a bathroom, and a septic tank. I got a rinse tub that we take a bath in. I'd rather have a bathtub, but meanwhile I can make do. I don't have a telephone and I don't want one. Telephones are a nuisance. But I ain't poor-poor. There's people worse off than I am. There's some people, they don't even got a house. They're probably what you'd call poor-poor.

But it sure is easier to live down here. If people just watch how people live around here, they could probably learn a lot, especially if they watch Iree. Iree's always had a hard life. She's raised big gardens, had to take care of lots of people over the years—all her brothers and sisters, her parents, too. She's never had much of nothing. I've learned from her how to work in a garden. Iree teaches me how to sew, too. I can sew alright now. When you're in a city you don't learn things like that, you don't even think about things like that. I never did. I sure didn't think about no garden. You just take things for granted up there. Stores are closer in the city, down here they're not; schools are closer, here they're far away.

Like I don't mind Jeremy going to school now. It's just that he travels too far and I don't like the road he has to travel on. I wish the school was still down the bottom of the hollow where it was when I first moved

WANDA BOWLING, ONE OF THE
THREE SISTERS FROM CINCINNATI,
WITH HER HUSBAND NEIAL AND
THEIR SON JEREMY, AGE TEN.

here. And yeah, I could take my kid out of here OK, but look what you'd have to live in. I don't want to have to sit and worry about my kid all the time. And down here you don't.

For Jeremy, school's important. He's really a smart kid. He's in the fourth grade this year. You want your kid to have a good education. Buckhorn's alright as a school—they got some good teachers and some bad. But you know I want my kids to do better than what I done. 'Cause I just finished school this past year, I just got my GED [high school graduate equivalence diploma]. See, I quit school in the eighth grade—which was stupid.

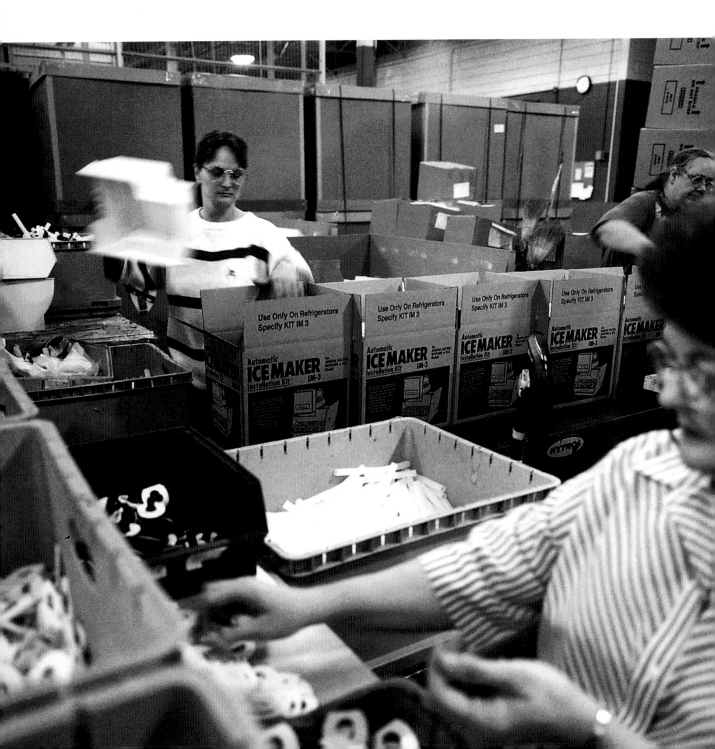

I was on welfare before I started this GED. My mother, she had cancer, I don't really like to talk about it. But back then I started taking these CNA classes, that's Certified Nurses' Aide. I got my license for that, too. I was taking classes for that in Clay County, up there at a nursing home. I was going like three times a week, it wasn't much. I think I did seventy-five hours.

This all went through the welfare; the welfare helped me get this. And after that I decided I'd try to get my GED. But as I told Neial, it was just for me, I really wanted to do it because I never finished school. So I tried for my GED and I got that, too. My sisters and me—all three of us tried. We went to Leslie County Adult Learning Center, is what it's called. I got my GED through there. And then they were having some classes down in the hollow right in the community center. We tried to go every day, but we went every other day. Then you have to take a test in Hazard. You have to go to Hazard Community College to get your main test, see if you pass that.

And I've been working now for about three months. Samantha was telling me about her job. Samantha, that's Ivalene's girl. She was telling me they was hiring. I said, "Well, I'll go down there and put in an application." You got to have your GED to work there. Mid-South Electronics. They run ice-makers, they make Motorola phones, build oven roasters. God, they do all kinds of things there. We just ship ice-makers on the line I'm working on. We ship them out to, like, Japan and Mexico and somewhere else, I forget where they said. I work right on the line Samantha does.

To get to work we have to drive an hour and a half. Samantha picks me up and drives. We work a nine-hour shift, from 4:30 in the afternoon 'til 2:00 in the morning. So I leave home at 3:00 in the afternoon and come back at 3:30 in the morning. Then I have to get right back up at 5:30 to get Neial ready for work and then to get Jeremy up at 6:00 for school. Neial takes care of Jeremy at night five days a week when I'm working. Neial works in the morning and is back home at 5:30 or 6:00. So I just see him on the weekends and in the mornings.

Still, generally I like what I'm doing now. I get along with everybody on the line. Most of the folks live down there around where the plant is in Jackson. Very friendly. I even like our line boss, Darla.

We put out, I'm going to say, about twenty skids a night. To me, I don't work hard. It's just steady runs and you can't stop, you know, except on your breaks. We get one, two, three—four ten-minute breaks and a thirty-minute lunch break. And your bathroom breaks, which are like five minutes. But I promise you, in a nine-hour shift, we can load up one of them big trucks.

MID-SOUTH ELECTRONIC, JACKSON,
KENTUCKY. WANDA PACKING ICE-MAKERS
BOUND FOR JAPAN, MEXICO, AND ELSEWHERE.
SAMANTHA CANADA ALSO WORKS THERE.

jeremy bowling

It's not that I don't like school. I like what classes I have and everybody that goes there. There's probably about twenty-three kids in the whole class and the whole class is my best friend. I got probably about 200 best friends. I have two teachers, one's for English and one's for the rest. I take math, science, social studies, reading, and English. And I like them all, but science is my favorite. This year we studied volcanoes, earthquakes, and rain forests. Right now over half the rain forest is gone and soon there won't be none left.

In the morning, a little bus runs up to the holler. About ten or eleven kids take the little bus, one of them's my cousin and the rest are other kids—just

WANDA HELPS HER SON JEREMY WITH HIS HOMEWORK, WHILE HIS COUSIN, JOSH BOWLING, LISTENS.

"Somedays, when the snow comes just a little pepper down, we don't have to go to school!"

kids I know that's my friends. I'm ten, fourth grade. A big bus waits at the end of the holler and picks us up. And then it takes us on over to school. Some days if the snow comes just a little pepper down, even just a little bit, we don't have to go to school! 'Cause the roads can be dangerous, you know. The whole ride takes about forty-five minutes. We talk about model cars, or other stuff—just anything we can.

I like to talk about cars. I like HotWheels. I want a car, one of them convertibles. I want one of them that has the top you push the button and it goes backwards. And then you push it again and the top folds back up and it's a regular car. This summer I'll probably get my go-cart fixed and then go go-carting. Summer is my favorite time . . . 'cause I don't have school. I just play with my cousins and friends.

Ashley, Lisa, Brandy, Mitchell, Josh, Bubbie. Bubbie is my cousin Clintus. We call him Bubbie 'cause he's the oldest kid up here. I ride my go-cart, I ride my bicycle. I was just playing with Ashley. She was the tollbooth and I had to pay her fifteen dollars. I was riding my bicycle. I go running around too, and walking—just about anything I can do. There's lots of trees and mountains and valleys and lakes. Most of the stuff you'll see here is trees and mountains. It's pretty nice.

I've got three cats, Ally, Sasha and Star. Edith, she has tamed rabbits. Sometimes I go out there and pet them. And we have a dog named Dummy. When he was a little puppy he would run around and hit stuff, run into posts and all kinds of stuff. And we had a hunting dog too. She died. Her name was Jane.

I'm looking forward to seeing the book about us. I hear we're going to be in public libraries. You can learn a lot of what we do down here; how we live and what we do to have fun. They say if you read a lot you'll learn more and get more education. I get the books I read from school. First, I want to go to college. Then I'll probably help save the rain forest. I want to go out where there is a big place cut down, I'll go out and put in trees and stuff like that. But I'll probably live here too. I'd like to.

Bibliography

Adams, Sheila Kay. *Come Go Home With Me*. Chapel Hill: University of North Carolina Press, 1995.

Allison, Dorothy. *Bastard Out of Carolina*. New York: Dutton, 1992.

Baber, Bob Henry, George Ella Lyon, and Gurney Norman. *Old Wounds, New Words: Poems from the Appalachian Poetry Project*. Ashland, Kentucky: Jesse Stuart Foundation, 1994.

Barden, Thomas E. *Virginia Folk Legends*. Charlottesville: University Press of Virginia, 1991.

Bates, Artie Ann, and Jeff Chapman-Crane. *Ragsale*. Boston: Houghton Mifflin, 1995.

Berry, Wendell. *Another Turn of the Crank*. Washington, D.C.: Counterpoint, 1995.

———. *The Gift of Good Land*. Berkeley, California: North Point Press, 1981.

———. *What Are People For?* Berkeley, California: North Point Press, 1990.

Carawan, Guy, and Candie. *Voices from the Mountains*. Athens, Georgia: University of Georgia Press, 1996.

Caudill, Harry. *Night Comes to the Cumberlands*. Boston: Little, Brown & Co., 1974

Chase, Richard. *Grandfather Tales*. Boston: Houghton Mifflin, 1976.

———. *The Jack Tales*. Boston: Houghton Mifflin, 1971.

Chute, Carolyn. *Merry Men*. New York: Harcourt Brace, 1994.

Cunningham, Rodger. *Apples on the Flood: Minority Discourse and Appalachia*. Knoxville: University of Tennessee Press, 1987.

Davis, Donald. *Jack Always Seeks His Fortune*. Little Rock: August House, 1992.

Eller, Ronald D. *Miners, Millhands and Mountaineers: Industrialization of the Appalachian South, 1880-1930*. Knoxville:
 University of Tennessee Press, 1982.

Ewald, Wendy. *Portraits and Dreams: Photographs and Stories by Children of the Appalachians*. New York: Writers and Readers Publishing, 1985.

Fisher, Stephen L. *Fighting Back in Appalachia: Traditions of Resistance and Change*. Philadelphia: Temple University Press, 1993.

Giardina, Denise. *Storming Heaven*. New York: W.W. Norton & Co., 1987.

———. *The Unquiet Earth*. New York: W.W. Norton & Co., 1992.

Green, Archie. *Only a Miner: Studies in Recorded Coal-Mining Songs*. Champaign, Illinois: U. of Illinois Press, 1972.

Higgs, Robert J., Ambrose Manning, and Jim Wayne Miller. *Appalachia Inside Out. Vol. 1, Conflict and Change*. Knoxville:
University of Tennessee Press, 1995.

———. *Appalachia Inside Out. Vol. 2, Culture and Custom*. Knoxville: University of Tennessee Press, 1995.

Isbell, Robert. *The Last Chivaree: The Hicks Family of Beach Mountain*. Chapel Hill: University of North Carolina Press, 1996.

Keith, Jeanette. *Country People in the New South: Tennessee's Upper Cumberland*. Chapel Hill: University of North Carolina Press, 1995.

Maxine, Kenny, and Appalshop. *Tell It on the Mountain: Appalachian Women Writers*. Whitesburg, Kentucky: WMMT, 1995.

Lewis, Helen M., and Suzanna O'Donnell. *Remembering Our Past, Building Our Future*. Ivanhoe, Virginia: Ivanhoe Civic League, 1990.

———. *Telling Our Stories, Sharing Our Lives*. Ivanhoe, Virginia: Ivanhoe Civic League, 1990.

Lyon, George Ella, Jim Wayne Miller, and Gurney Norman. *A Gathering at the Forks*. Wise, Virginia: Vision Books, 1993.

McCarthy, William Bernard. *Jack in Two Worlds: Contemporary North American Tales and Their Tellers*. Chapel Hill:
 University of North Carolina Press, 1994.

McCauley, Deborah Vansau. *Appalachian Mountain Religion: A History*. Champaign, Illinois: University of Illinois Press, 1995.

McClanahan, Ed. *The Natural Man*. New York: Farrar, Straus, and Giroux, 1983.

McNeill, Louise. *Gauley Mountain: A History in Verse*. Dunmore, West Virginia: Pocahontas Communication Cooperative, 1996.

Manning, Russ. *The Historic Cumberland Plateau: An Explorer's Guide*. Knoxville: University of Tennessee Press, 1993.

Mielke, David N. *Teaching Mountain Children. Towards a Foundation of Understanding*. Boone, North Carolina:
 Appalachian Consortium Press, 1978.

Norman, Gurney. *Divine Rights Trip: A Novel of the Counterculture*. Frankfort, Kentucky: Gnomon Press, 1972.

———. *Kinfolks: The Wilgus Stories*. Frankfort, Kentucky: Gnomon Press, 1977.

Norris, Randall, and Jean-Philippe Cypres. *Women of Coal*. Lexington: University Press of Kentucky, 1996.

Offutt, Chris. *The Good Brother*. New York: Simon & Schuster, 1997.

———. *Kentucky Straight*. New York: Vintage Books, Random House, 1992.

———. *The Same River Twice*. New York: Simon & Schuster, 1993.

Pancake, Breece D'J. *The Stories of Breece D'J Pancake*. New York: Owl Books, Holt Rinehart and Winston, 1983.

Perdue, Charles L., Jr. *Outwitting the Devil: Jack Tales from Wise County, Virginia*. Santa Fe, New Mexico: Ancient City Press, 1987.

Pudup, Mary Beth, Dwight B. Billings and Altina L. Waller. *Appalachia In the Making: The Mountain South in the Nineteenth Century*. Chapel Hill:
 University of North Carolina Press, 1995.

Roberts, Leonard W. *Sang Branch Settlers: Folksongs and Tales of a Kentucky Mountain Family*. Pikeville, Kentucky: Pikeville College Press, 1980.

Schenkkan, Robert. *The Kentucky Cycle*. New York: Plume, Penguin Books, 1993.

Slone, Verna Mae. *What My Heart Wants To Tell*. Lexington: University Press of Kentucky, 1979.

Still, James. *River of Earth*. Lexington: University Press of Kentucky, 1978.

Stoddart, Jess. *The Quare Women's Journals: May Stone and Katherine Pettit's Summers in the Kentucky Mountains and the Founding of the Hindman
 Settlement School*. Ashland, Kentucky: Jesse Stuart Foundation, 1997.

Verghese, Abraham. *My Own Country: A Doctor's Story of a Town and its People in the Age of AIDS*. New York: Simon & Schuster, 1994,

Waller, Altina L. *Feud: Hatfields, McCoys, and Social Change in Appalachia, 1860-1900*. Chapel Hill: University of North Carolina Press, 1988.

Williams, Cratis D. *I Become A Teacher: A Memoir of One-Room School Life in Eastern Kentucky*. Ashland, Kentucky: Jesse Stuart Foundation, 1995.

———. *Southern Mountain Speech*. Berea, Kentucky: Berea College Press, 1992.

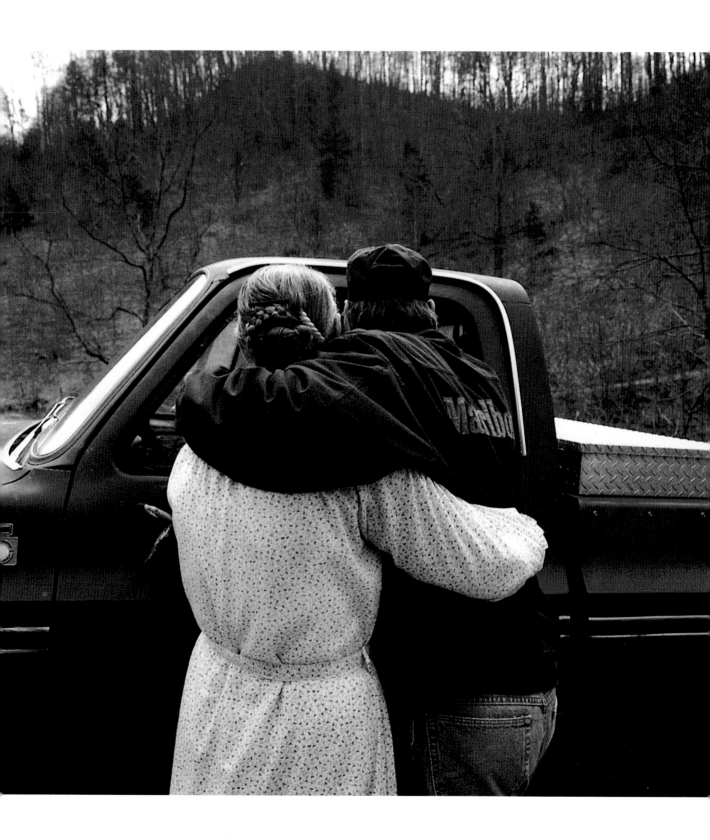

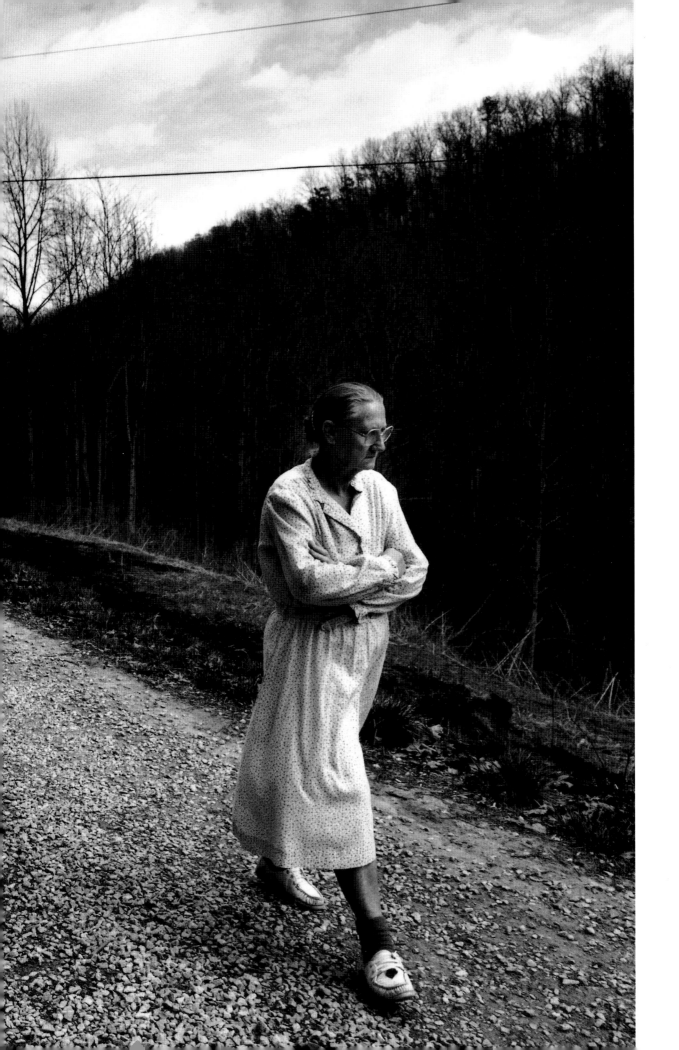

Acknowledgments

I dedicate this book to my brother Michael, whose encouraging words helped me start *American Hollow* and whose enduring spirit helped me to finish it. And to John, Carolyn and Lauren, whose goodness and beauty made bright the dim world. I also dedicate this to the memory of my father, to my mother, and to my brothers and sisters—for teaching me the meaning of family.

American Hollow was created with the help of many. I am most grateful to the Bowlings for treating me like family and opening my eyes to a new, yet familiar world. Specifically thanks to Iree for her strength and wisdom and to her and Bass for letting us live in their home; to Neial and Wanda and Jeremy for giving up their bed (only the beginning of their hospitality); to Ruthie and Chester and their children, and David and Irene and their children, as well as to Marion Williams—for sharing so much of their lives with me. Thanks to Polly, Clint, and Josh for always opening the door warmly and to Lonzo for his humor (and coffee!); to Samantha for her courage; and to Bob and Ivalene for their kindness and warmth, and to Kendra and Deana for being such great kids. I thank Pat and Edith, Brandy, Lisa, and Ashley for taking us hunting and other adventures, and all the other members of the Bowling clan for their generosity and patience.

I am particularly appreciative of Dr. Robert Coles for his insightful introduction. It is truly an honor to have his name associated with the book. Nan Richardson, who approached it as a labor of love, is responsible for making this book happen. Thanks to Nan for her intelligence and insights in pulling all the pieces together—a crazy quilt. Many of the Bowlings consider Steve Lehman family and that connection comes through in his sensitive and insightful photographs. Steve's vision shaped this project, as did his commitment and dedication. I am indebted to Mark Bailey, whose sensitively written proposal encouraged HBO to commit to a film before it was shot and made Bulfinch enthuse about a book before it was written. His talents were further realized in his ability to synthesize hours upon hours of interviews into a comprehensive and moving narrative. I couldn't ask for a better partner, in work as well as in life. Thanks to Eric Baker and his team—Tika Buchanan and Fiona Lumsden—for strong and inspired design, to Amie Cooper for her cheerful production assistance, and to Everbest for their great printing job. Thanks to assistant editors James Askin, who worked on the initial proposal, as well as Rula Razek, Xenia Cheremeteff, Becca Burns, Laurent Gorse, Anna Nordberg and Eithne Richardson who worked tirelessly on deadline to make it a success, and to Elaine Luthy for her copyediting expertise. I am deeply grateful to Carol Judy Leslie, the head of Bulfinch, who so believed in this book that she committed to it at thirty thousand feet—we hope it is all you imagined and thank you for your faith, and to the excellent and energetic Sarah Kirshner, managing editor extraordinaire, and marketing and publicity experts Lyndsay Hanchett and Katie Long, who threw their considerable combined force into the effort.

American Hollow was initially conceived of as a film and would not have evolved without the support and vision of Sheila Nevins at HBO. She was willing to take a risk when no one else would, and for that I remain forever grateful. Jackie Glover recognized the potential for a film from the beginning and was a pleasure to work with throughout. Sheila, Jackie, and Zack Morfogen are responsible for the initial idea to do a book, and I am grateful to Zack for his continued commitment and support. I wish to further thank others involved with the film upon which much of this book is based: Nick Doob lived with the Bowlings and me, and much of *American Hollow* stems from his influence; in the edit room, Adam Zucker helped mold the film and tell the story Nick and I had captured. Thanks to Bill Frisell for his music and Erica Euler for her hard work. I am grateful to Nancy Abraham, June Winters, Bill Chase, Peter Rienecker, and Matthew Morris for their behind-the-scenes efforts at HBO. Thanks to Anthony Williams and Richard Gorelick for their legal advice, and to Karen Cooper and Mike Maggiore at the Film Forum. Neil Watson at the Norton Museum of Art deserves special thanks for his critical curatorial contributions to the exhibition. Thanks to Gerry Kavanaugh for facilitating the exhibition and screening. I also deeply appreciate The Joseph P. Kennedy, Jr. Foundation's financial support of the exhibition.

I am grateful to Liz Garbus for her support and partnership, Barbara Muncy and Lynn Maggard at the University of Kentucky Center for Rural Health for introducing me to the Bowlings, and Deborah Paulhus, whose love for children helped bring about my first trip to Appalachia. Many others provided valuable insights and support: all the folks at Appalshop and the University of Kentucky Center for Rural Health, as well as Eric Anderson, Yvonne Anderson, Edward Bailey, Madalyne Bailey, Edward Beason, Joe Conason, Andrew Cuomo, Dee Davis, Cami Delavigne, Rhoda Glickman, Steven Johnson, Andy Karsch, Annie Keating, Katherine Kousi, D'Arcy Marsh, Danielle Mattoon, Charles Miller, Jesse Moss, Mike Oatman, Mimi Pickering, Alexa Robinson, Stephen Sherrill, Robin Smith, Pete Stein, Boo Trundle, Helen and Kevin Ward, and Elizabeth Wagley, all of whom helped guide me in putting together *American Hollow*.

796.9
Ken

American Hollow by Rory Kennedy
Copyright © 1999 Umbrage Editions

Photographs Copyright © 1999 by Steve Lehman
Interview Texts Copyright © 1999 by Mark Bailey
Introduction Copyright © 1999 by Rory Kennedy
Foreword Copyright © 1999 by Robert Coles

All rights reserved. No part of this book may be reproduced in any form or by any electronic or mechanical means, including information storage and retrieval systems, without written permission from the publisher, except by a reviewer who may quote brief passages in a review.

First Edition
ISBN 0-8212-2631-2

Library of Congress Catalog Card Number 99-6524 1

Produced by:
Umbrage Editions, Inc.
515 Canal Street
New York, New York 10013

Project Director: Nan Richardson
Assistant Editors: Camille Robcis, James Askin and Xenia Cheremetieff
Consulting Editor: Eithne Richardson
Editorial Assistants: Becca Burns, Laurent Gorse, Annett Heibel, Grazyna Guzik-Mactier, Glada Ripa di Meana, and Anna Nordberg
Production Coordinator: The Actualizers
Designer: Fiona Lumsden/Eric Baker Design Associates, Inc.

The generous support of the following individuals and foundations made this book and its accompanying exhibition possible:
Sidney Kimmel
The Joseph P. Kennedy, Jr. Foundation
The M.L. Ward Foundation

While we would have loved to include every member of the Bowling clan in this book and film, we were limited by time (and the fact that some members chose not to participate). Every effort was made to correctly identify the individuals in the book; we sincerely apologize for any inadvertent mistakes. –*The Authors*

The *American Hollow* exhibition of photographs, organized by The Norton Museum of Art and Umbrage Editions, will open on November 8, 1999 at The Capitol, Senate Rotunda Gallery, Washington, D.C., and and travel through 2001 to the following venues;
The Dayton Art Institute, Dayton, Ohio
The Maryland State House, Annapolis, Maryland
The Norton Museum of Art, Palm Beach, Florida

Bulfinch Press is an imprint and trademark of Little, Brown and Company (Inc.)

PRINTED IN CHINA